# TUNBRIDGE WELLS
## THROUGH TIME
Robert Turcan

AMBERLEY

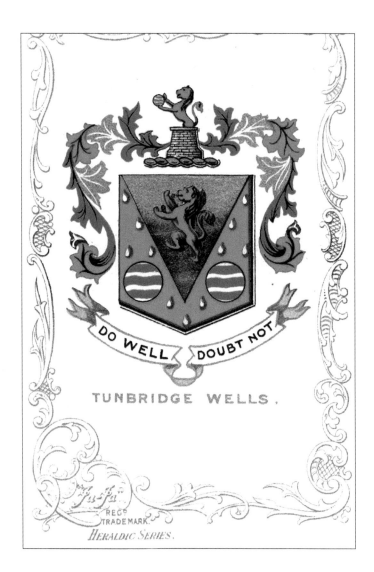

DO WELL — DOUBT NOT

TUNBRIDGE WELLS.

REG<sup>D</sup> TRADE MARK.
*Heraldic Series.*

First published 2012

Amberley Publishing
The Hill, Stroud
Gloucestershire, GL5 4EP

www.amberley-books.com

Copyright © Robert Turcan, 2012

The right of Robert Turcan to be identified as the
Author of this work has been asserted in accordance
with the Copyrights, Designs and Patents Act 1988.

ISBN 978 1 4456 0821 1

British Library Cataloguing in Publication Data.
A catalogue record for this book is available from
the British Library.

Typeset in 9.5pt on 12pt Celeste.
Typesetting by Amberley Publishing.
Printed in the UK.

# Introduction

Tunbridge Wells was conceived as a future spa and holiday resort in 1606 when Lord North, a dissolute nobleman escaping London for health reasons, came upon iron-rich spring water, which he drank and subsequently decided it made him feel better. He sent samples back to the capital for physicians to analyse, and soon fellow gentry began arriving in ever increasing numbers to take the waters. At first these visitors had to camp in the countryside nearby, but eventually buildings developed providing accommodation for this affluent clientele.

The first permanent building was a church, which also served as an assembly room and shelter from inclement weather. Other facilities soon arose to cater for more frivolous activities such as boozing and gambling. The town's reputation as a fashionable destination grew quickly; Princess Anne is notable for her act of charity in providing finance for pantiles to be laid over the slippery path where her son had fallen. In time these pantiles were replaced by paving stones but they remain the town's most famous feature. Beau Nash treated Tunbridge Wells as a colony of Bath where he was also master of ceremonies. Strict social codes were observed and the walks were segregated between the gentry and lesser mortals.

By the Regency period a lot of building expansion was taking place. The great architect Decimus Burton had a great influence on Tunbridge Wells' appearance and many of his grand schemes were implemented. Cavalry Park in particular is probably the first gated housing estate to have been planned.

When the railway arrived in 1845 a great impetus for further housing expansion occurred. London was only an hour away, so desirable villas were constructed for metropolitan workers. Train travel also boosted tourist trade. Without heavy industry and high-value agricultural land, informal town planning achieved a desirable result. Even now parks, woods and commons fill and surround this town.

The variety of locally grown hard woods provided a raw material for making marquetry decorated souvenirs. These objects, which were often useful little boxes, became known as Tunbridge Wells' ware. A more significant economic activity was the emergence of large high class hotels. Some of these great buildings survive to still fulfil their original purpose, but others have been converted into luxury flats.

The surrounding countryside was traditionally forest and, because of its undulation and outcrops of sandstone rock, was a virtual wilderness before the spa's popularity. The picturesque nature of sites such as High Rocks and Rusthall Common made them ideal picnic spots for holidaymakers so horse-drawn barouches became available to hire.

Although still quiet and blessed with a genteel reputation, the streets are lined with modern, funky shops and lively cafés and bars. Time has been kind to this relatively new town, by Kentish standards. The old and new images juxtaposed here will illustrate this conservative approach to change, but will mostly celebrate the smartness of Tunbridge Wells' attraction.

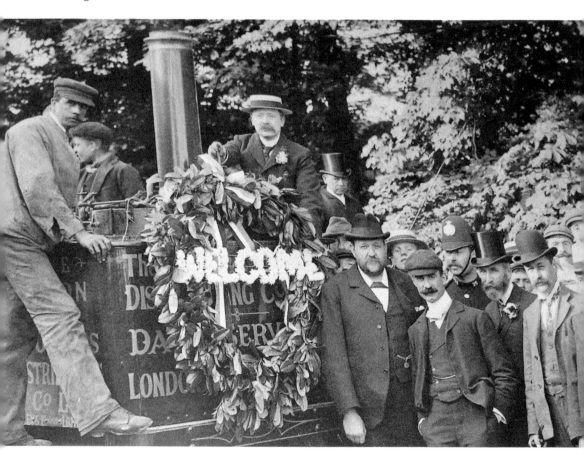

## Town Crier

Tunbridge Wells' Town Crier, resplendent in his maroon uniform, perfectly reflecting the town's Regency smartness. The whole town is indeed unusually attractive due to the variety and scope of its parks and open spaces. These are often broken by outcrops of sandstone such as the particularly well known Toad Rock at Rusthill Common.

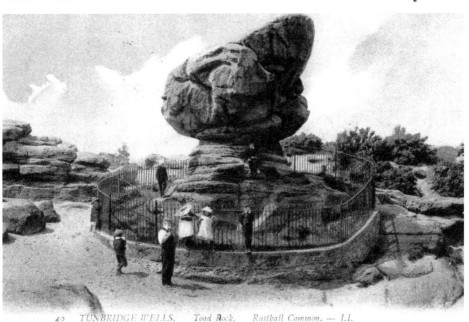

TUNBRIDGE WELLS. Toad Rock. Rusthall Common. — LL.

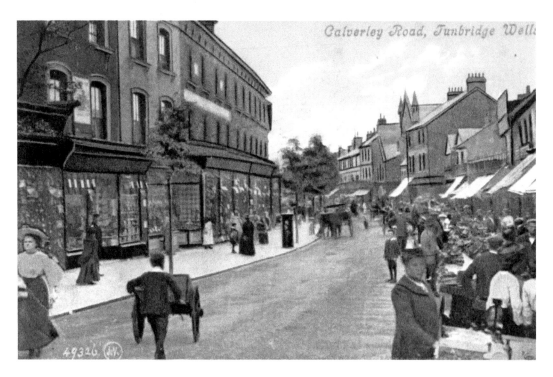

**Calverley Road**
Calverley Road greets visitors to the town travelling from north-east Kent. Once a busy area for traders market stalls, it is now restricted to pedestrians. Established trees flourish where carts and other vehicles at one time journeyed.

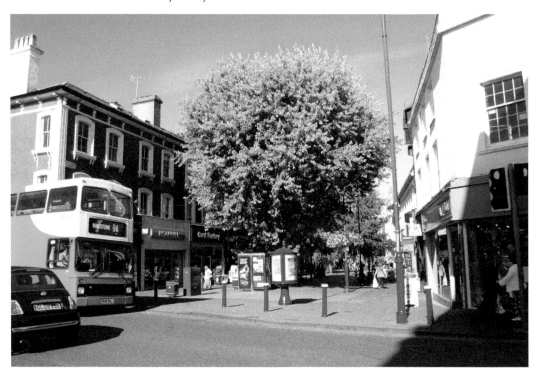

## Calverley New Town

Decimus Burton, who was a colleague and protégé of the Regency architect John Nash, designed the elegant Calverley Estate. His work had a profound influence on the fortunes of Tunbridge Wells. Brighton, with its new sea bathing fashion, was attracting popularity away from the spa. However, these grand designs for Britain's first gated community and 'garden' layout firmly established the town's reputation for gracious living and permanent elegance.

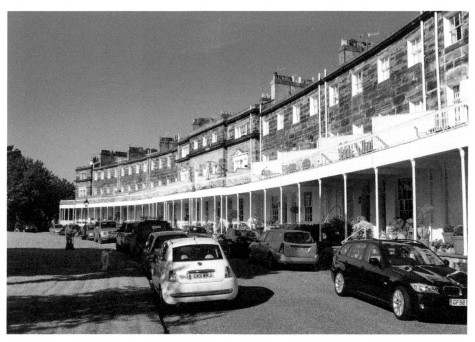

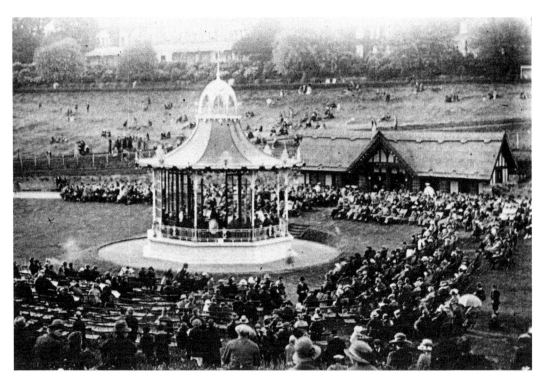

Pavilion Calverley Park

The bandstand, which first had an elaborate cupola and then a plainer roof, has disappeared from in front of the pavilion at Calverley Park. Meanwhile, the latter has had its thatched roof replaced with tiles and has become a popular café.

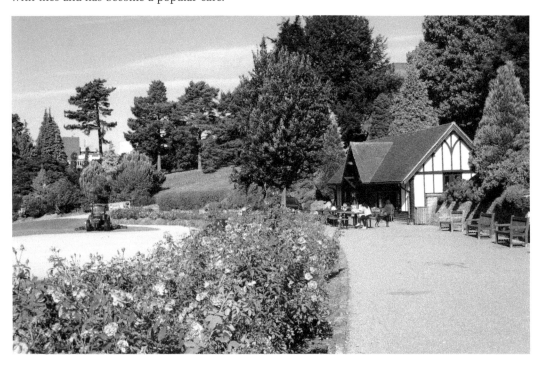

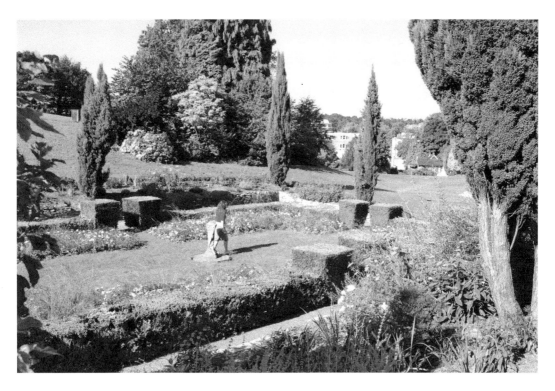

### Calverley Park's Gardens

Calverley Park's gardens were landscaped to enhance the setting of a curve of twenty-four large detached houses. These grounds are beautifully maintained and provide a wonderful open amenity for everyone to enjoy. Originally, however, they were for the exclusive use of residents and their servants only.

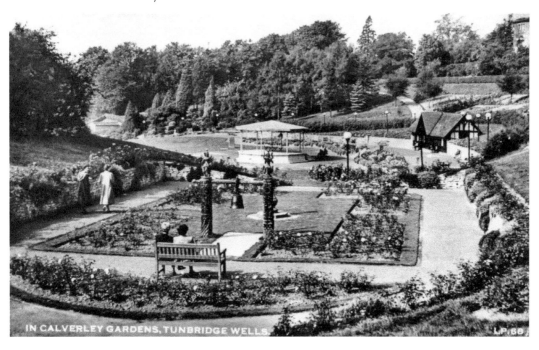

IN CALVERLEY GARDENS, TUNBRIDGE WELLS.          L.P.68

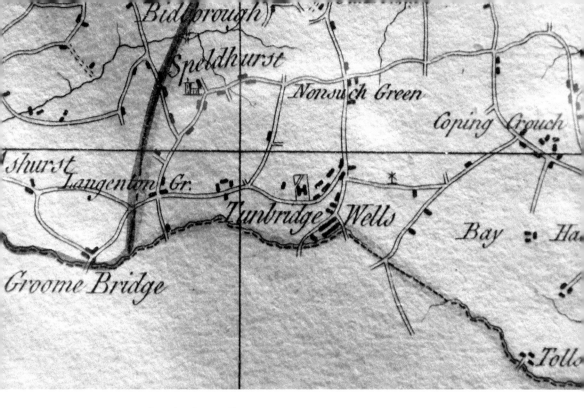

### Development of Tunbridge Wells I

The enlarged extract above from Laurie and Whittle's map, published in 1794, shows the line of earliest development in the valley where Lord North first discovered chalybeate spring water, just over 400 years ago. Below, the old, but larger scale map by Carey (1769) shows Tunbridge Wells' location on the High Weald next to the Sussex border.

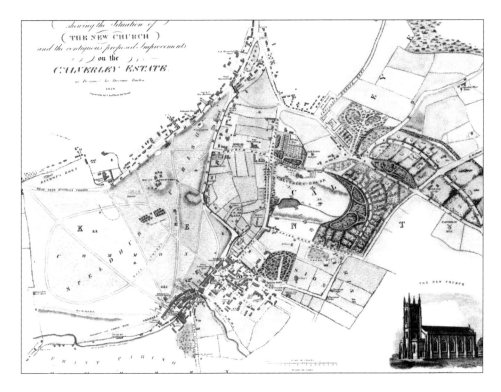

## Tunbridge Wells Development II

After the initial seventeenth- and eighteenth-century burst of growth as a fashionable resort, Tunbridge Wells developed into a town where affluent businessmen and professionals wished to settle. The plans above for the Calverley Estate were devised in the early nineteenth century and in the following years the town grew to its present population of well over 70,000.

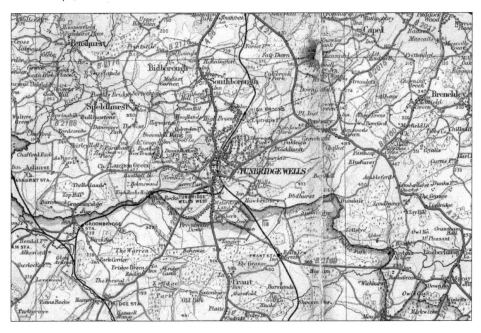

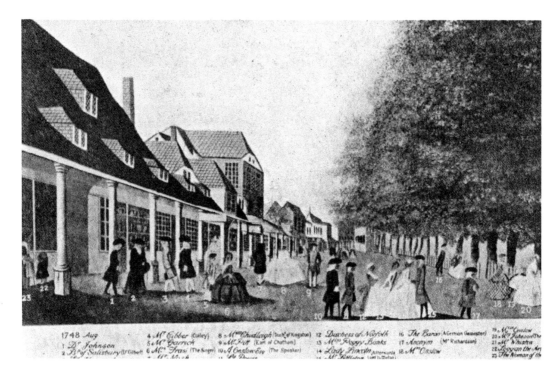

1748 Aug
1 Dr Johnson
2 Bp of Salisbury (Dr Gilbert)
4 Mr Cibber (Colley)
8 Mr Garrick
6 Mrs Frasi (The Singer)
8 Mrs Chudleigh (Dutch of Kingston)
9 Mr Pitt (Earl of Chatham)
10 Mr Onslow Esq (The Speaker)
12 Duchess of Norfolk
13 Mrs Peggy Banks
14 Lady Lincoln Afterwards
16 The Baron (A German Gamester)
17 Anonym (Mr Richardson)
18 Mr Onslow
19 Mrs Onslow
20 Mrs Johnson
21 Mr Whiston
22 Beggar the boy
23 The Woman of the

### The Pantiles Colonnade

The delightful colonnaded walkway known as the Pantiles has become the most recognisable view of Tunbridge Wells. The 'walks' as they were called in Georgian times were strictly governed by a protocol, implemented by renowned Richard Beau Nash. His policy was to ensure that the higher pathway was for the use of the gentry exclusively. Today this is now a vibrant area for all to widely enjoy.

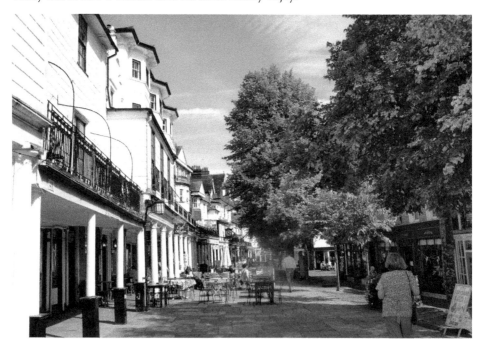

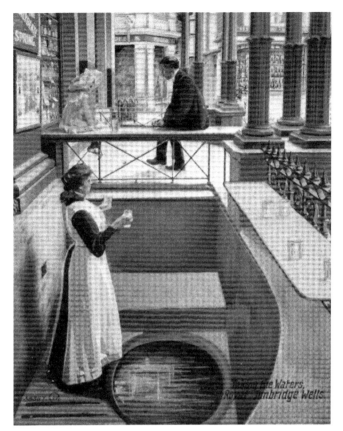

### The Chalybeate Spring

The discovery by Lord North of the Chalybeate Spring in a wooded valley, while on a hunting excursion in 1606, was to be the main spring for this town's establishment and growth. The brown mineral waters were thought to have medicinal benefits and the structures shown on this page were built around the underground source to serve customers' needs.

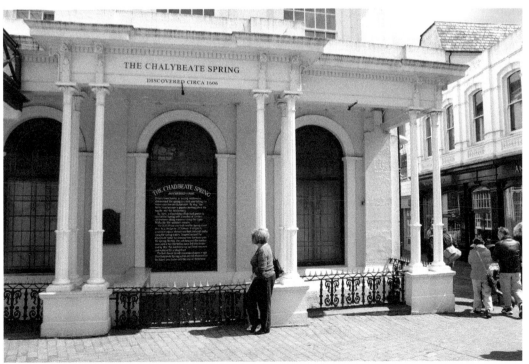

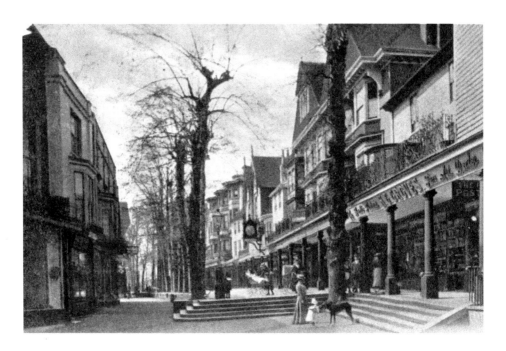

## Preservation and Conservation of the Pantiles

Much of Tunbridge Wells, which by British stands is a relatively young town, was so well conceived and built that its intrinsic elegance has remained intact. Over the centuries repairs and necessary replacements to the Pantiles have taken place. However, these attractive views illustrate how little of this relaxed, yet smart town has changed and how its original period properties have been so beautifully preserved.

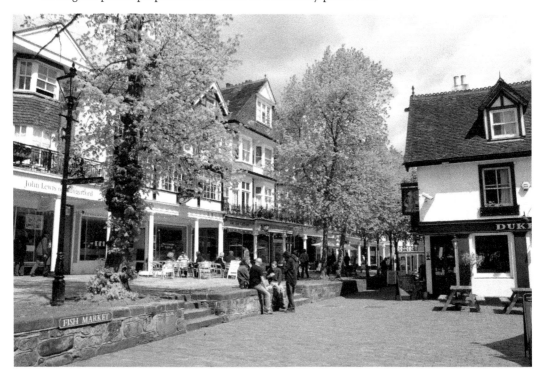

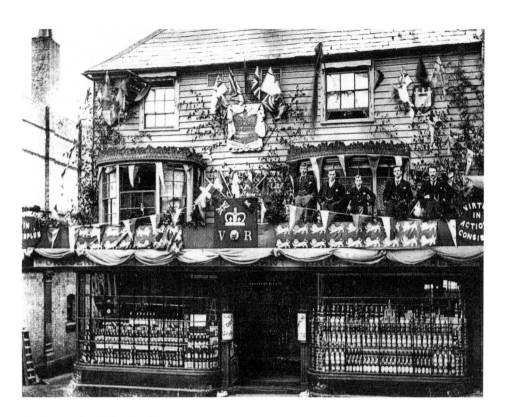

## Gastronomia at the Pantiles

The pretty eatery known as Gastronomia in the Pantiles is pictured below on a late summer afternoon, with its gingham clothed tables spilling out on to the pavement. Above, the same building was photographed for posterity in 1897 when it was festooned with bunting celebrating the Diamond Jubilee of Queen Victoria.

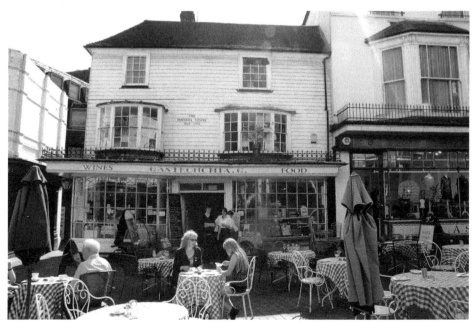

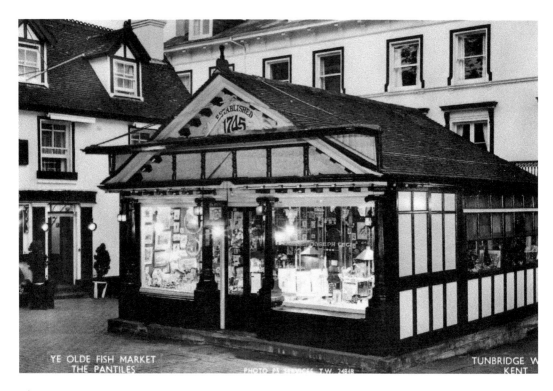

Ye Olde Fish Market at the Pantiles

Established as a fish market in 1745, the low detached structure illustrated here has now become a centre for tourist information. Its location could not be more perfect, as throughout history visitors have flocked to this town's unique epicentre of the Pantiles.

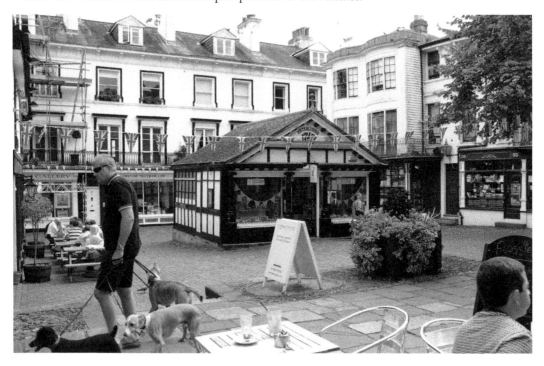

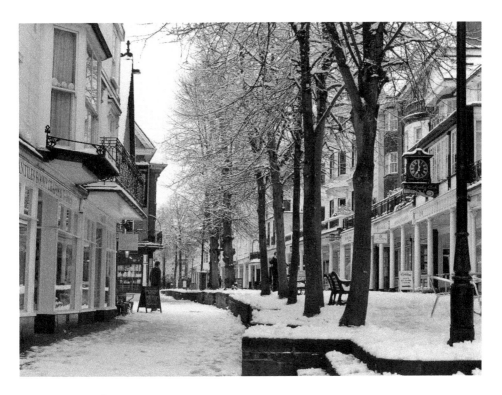

In the Deep Midwinter

The Pantiles are so attractive they look good in all seasons. These lovely photographs were taken by a local resident in the winter of 2008 and they artistically capture the still, quiet mood of the town after heavy snowfall.

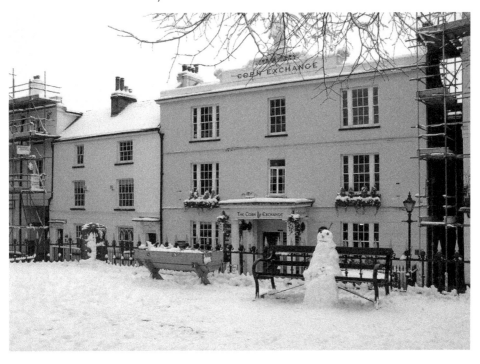

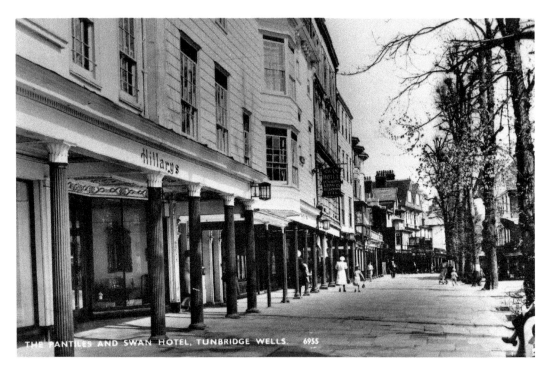

THE PANTILES AND SWAN HOTEL, TUNBRIDGE WELLS. 6955

**Swan Hotel**

The Swan Hotel pictured here in the centre of the Pantiles is well placed for visitors who attend the August music festival and others who just wish to enjoy the town's historic attractions or browse among the many independent retailers' shops.

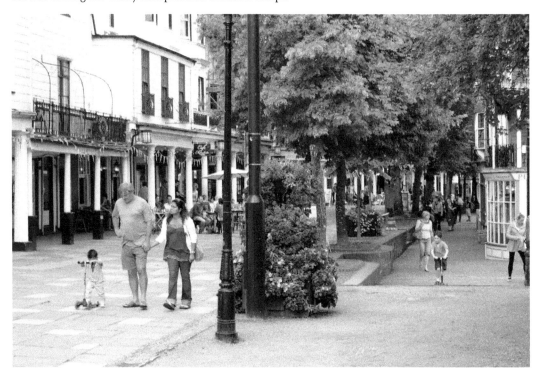

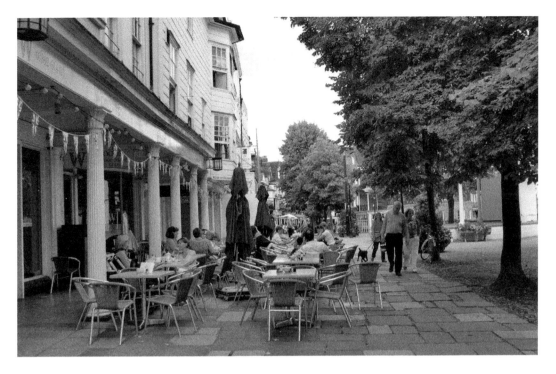

## Changing Dress Codes

While the built-environment of the Pantiles has changed in only minor detail over the past hundred years there has been a sea-change in the style of peoples clothing. The Edwardian postcard image below shows ladies wearing long, flowing dresses and large hats. Meanwhile, men are also similarly formerly attired in suits and *de rigueur* hats. The current trend pictured above is for a much simpler, more relaxed approach.

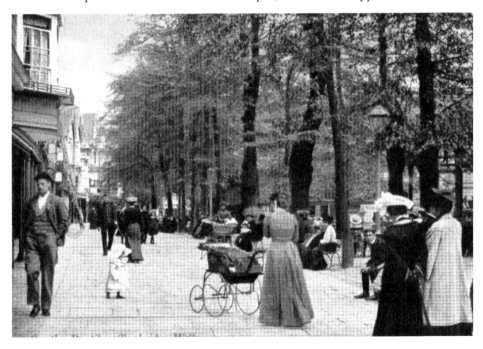

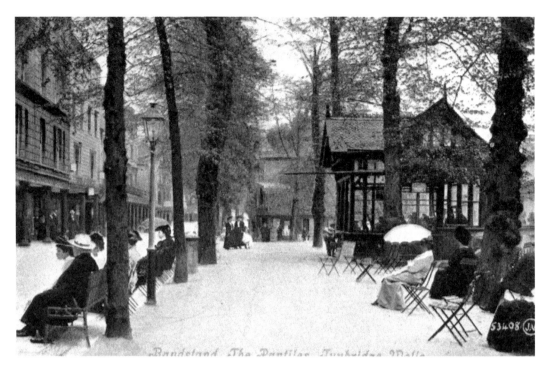

## Al Fresco Pantiles

The Victorians photographed above listening to music, near the bandstand, with their parasols and panamas, look just as relaxed as the present throng below, refreshing themselves outside in the warm sunlight.

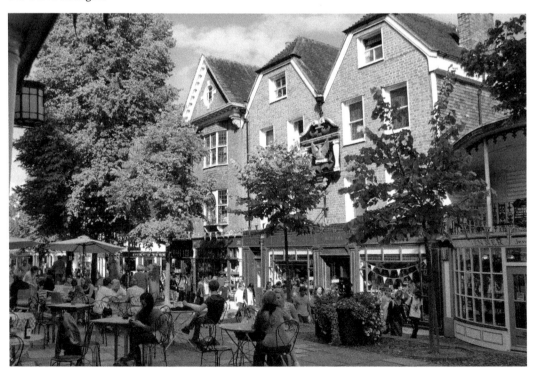

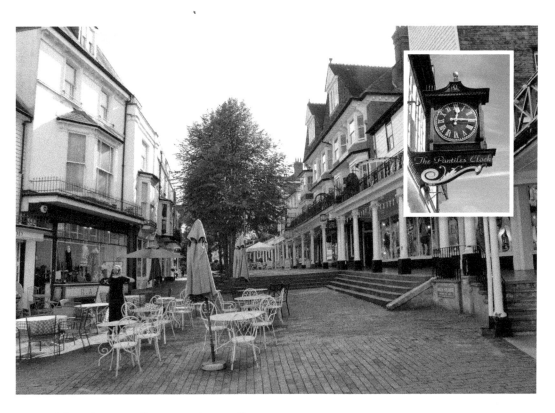

## High and Low Walkways at the Pantiles

These 'then and now' shots of the Pantiles are taken at an angle which gives a good illustration of the designed difference in height of the paved walkways. The original ceramic tiles from which the Pantiles name was derived were financed from a donation from Princess Anne in around 1700. She made this generous gesture after her son the Duke of Gloucester had fell on slippery ground near the spring.

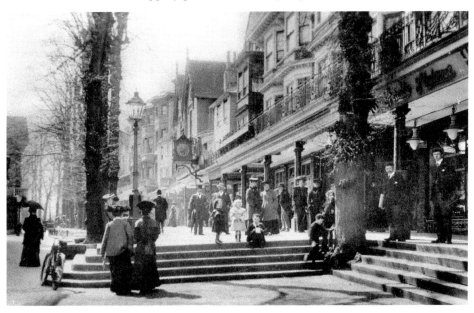

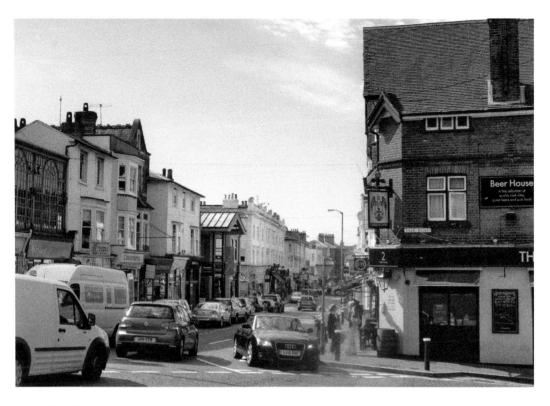

## High Street I

Apart from the obvious transformation in traffic from horse-drawn to motorised, this end of the High Street has seen the disappearance of the church tower below. An excellent Christian café has been established in the new building, however, with an entrance canopy that juts into the pavement where a tree once stood.

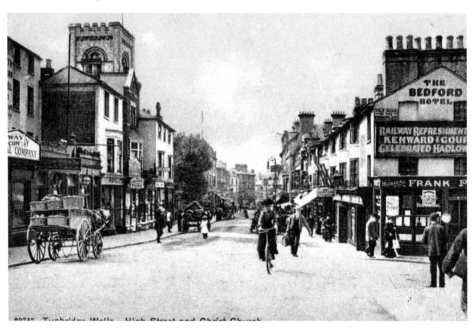

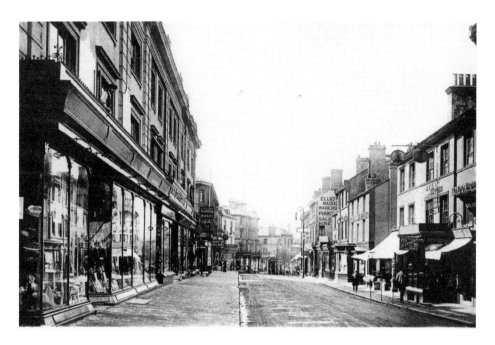

## High Street II

The section of Tunbridge Wells High Street pictured here has always comprised good quality shops stocking specialist items. However, in the top sepia image the advertising slogan on the end building, showing elevation for sheet music and pianos, would only now appeal to a much more limited market.

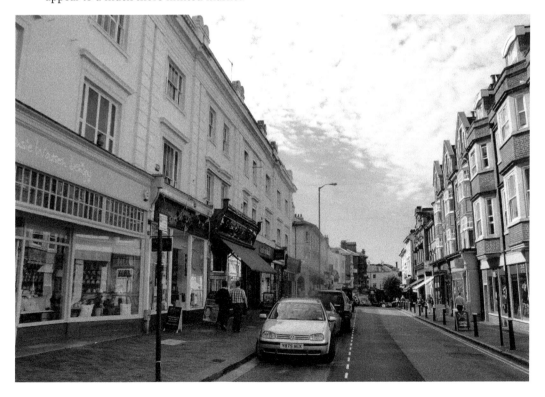

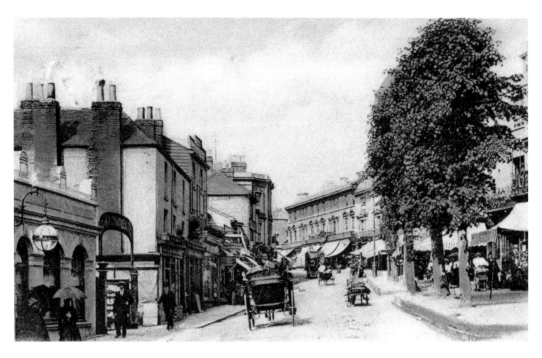

## High Street III

These old postcard scenes of the High Street display its grand character. In one a groom wearing a top-hat, at the reigns of a carriage, is waiting for his employers while they shop. Canvas awnings from shop fronts were an almost universal feature then and have only in more recent years begun to decline.

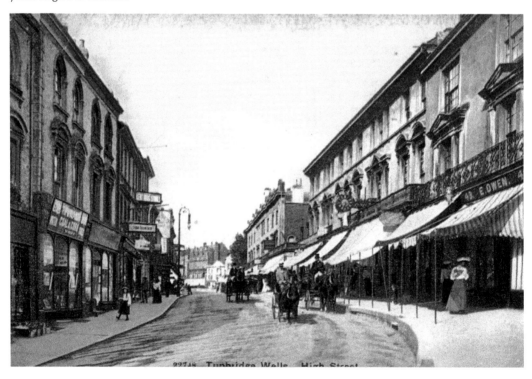

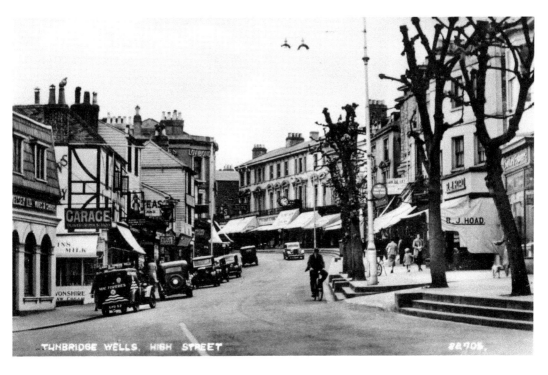

## High Street IV
In the 1930s photograph above car parking has just started to become an issue, but it was another thirty years before double yellow lines were introduced.

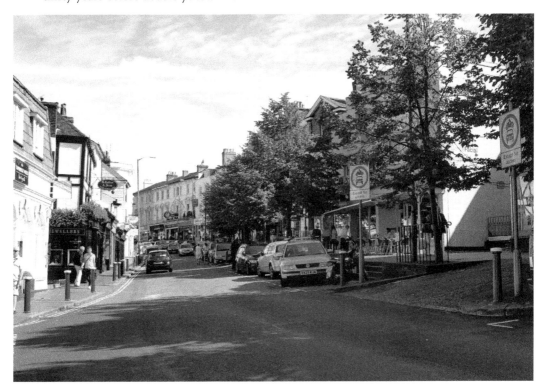

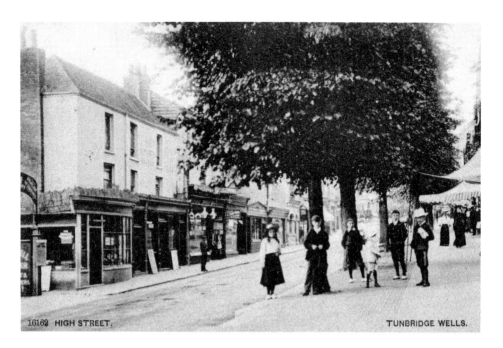

16162 HIGH STREET, TUNBRIDGE WELLS.

High Street V

In late Victorian and early Edwardian times photographers attracted a lot of attention from passersby who were intrigued by this relatively new technology. Many outside snapshots from this time include groups of interested children gazing at the cameraman – such as the one above. Today, with the prevalence of digital photography, the only comment received from passersby is the occasional catcall from a bored yahoo.

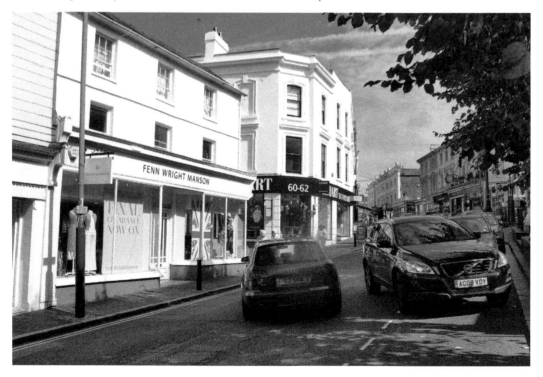

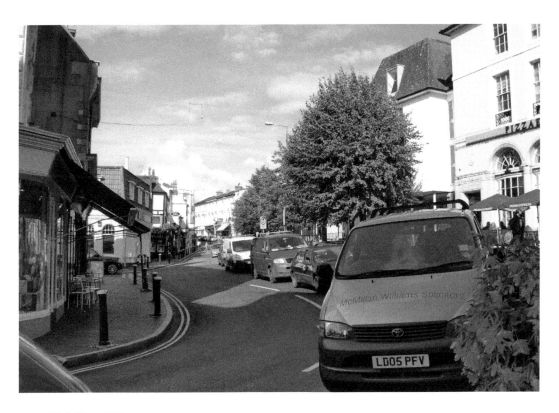

### High Street VI

Tunbridge Wells could be described as the original garden town with its diverse parks and commons. However, you will see from these before and after scenes that the municipal authorities have always paid particular attention to urban landscaping with lots of trees softening the lines of buildings.

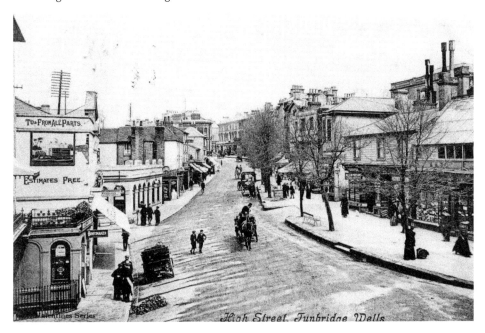

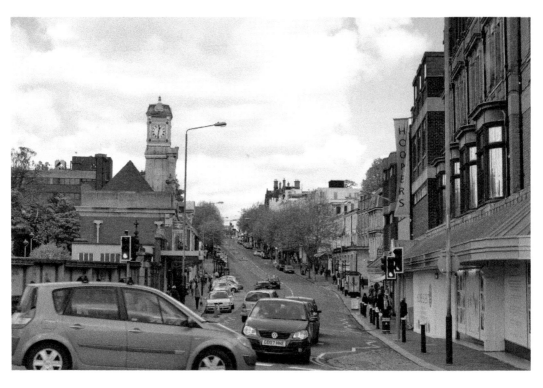

## The Railway Station I

In the old picture below, taken in the 1920s, motor cars were taking over from horse-drawn vehicles. Here, Austin 7s and pony traps jostle outside of Tunbridge Wells' main railway station.

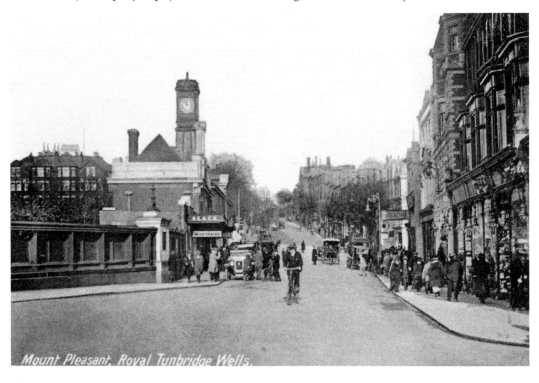

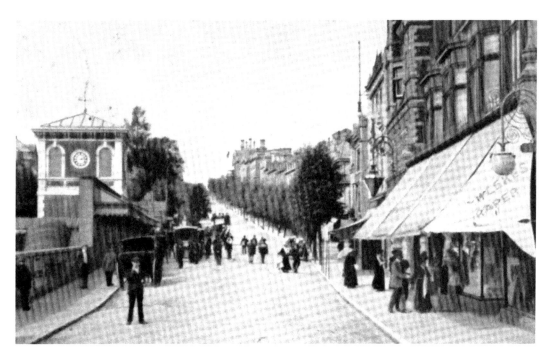

### The Railway Station II

Before the advent of motor cars, trains were the principle means of long distance travel. With its close proximity to London, Tunbridge Wells is convenient for commuters and the importance of this link was emphasised at the outset by the substantial scale of the station buildings with their clock tower embellishments.

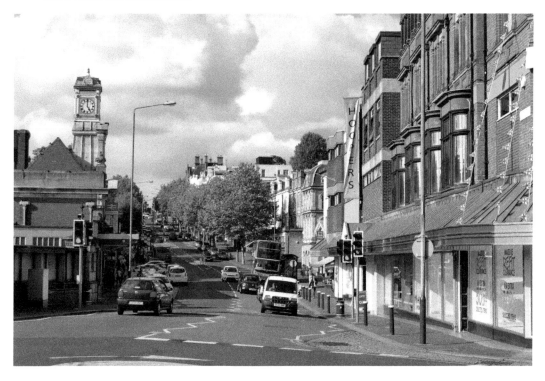

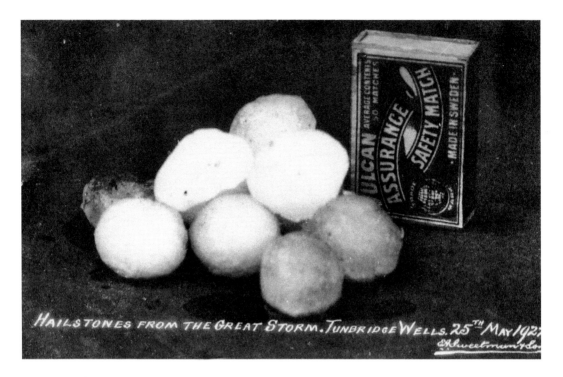

HAILSTONES FROM THE GREAT STORM. TUNBRIDGE WELLS. 25TH MAY 192?

EH Sweetmun + So.

### Freak Weather Events

The hailstones above fell during one of Kent's most intense storms on 25 May 1925. Many press photographs survive showing this freak weather event, illustrating large piles of ice cleared by council workers. Below, flood waters are also causing concern for workmen endeavouring to unblock drains at the lower end of Mount Pleasant Road.

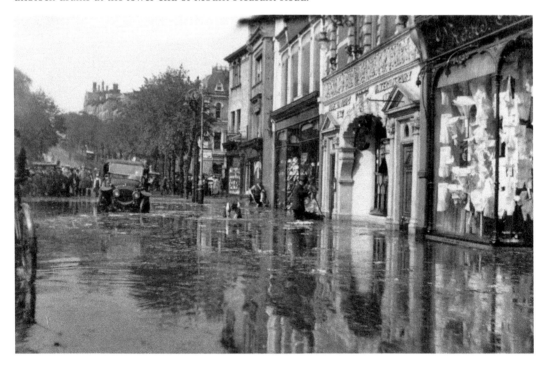

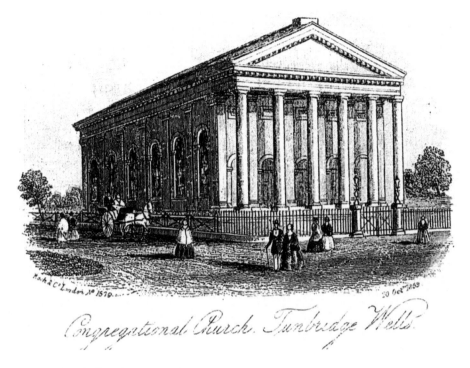

*Congreagntional Church, Tunbridge Wells.*

**Congregational Church Mount Pleasant**

This strikingly superb stone building in Mount Pleasant Road was lavishly equipped after it was built in 1848. Its handsome Grecian portico was added later. Now, sadly, it has lost its original religious use and is occupied for commercial purposes.

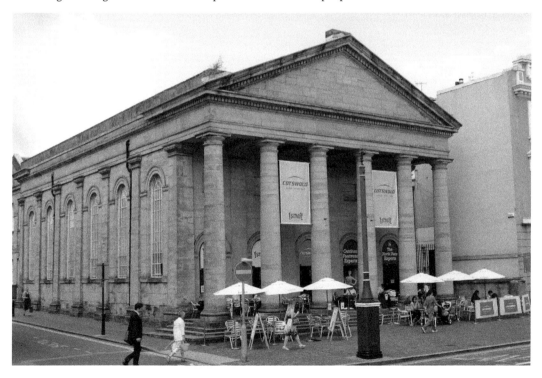

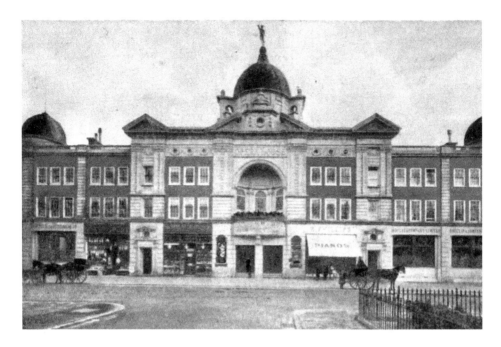

**The Opera House, Tunbridge Wells**

The magnificent Tunbridge Wells Opera House was opened in 1902 by Mayor W. H. Deaves and the well known Edwardian actor Sir Beerbohm Tree. It provided a seating capacity of 1,100 with a surprisingly small auditorium and stage. After becoming a cinema in 1931, and then a bingo hall, it is currently a pub. Considering both the retained originality of both its external and interior fabric, it is surprising that in a town of cultural awareness a more apposite purpose was not achieved.

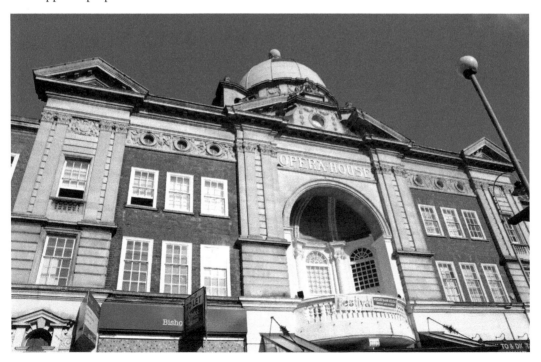

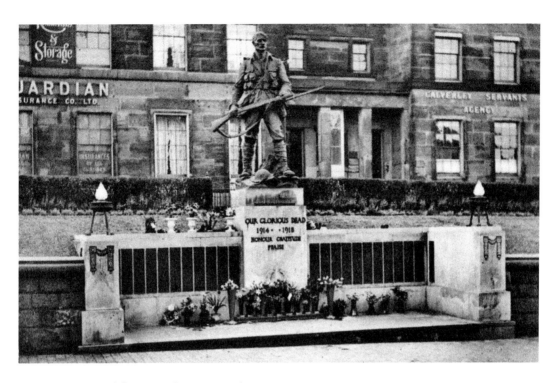

## War Memorial Mount Pleasant Road

The War Memorial in Mount Pleasant Road was rightly given Grade II listed status after a recommendation from English Heritage in 2011. The monument, featuring an infantry soldier, was designed by Stanley Nicholson Babb and unveiled in 1923.

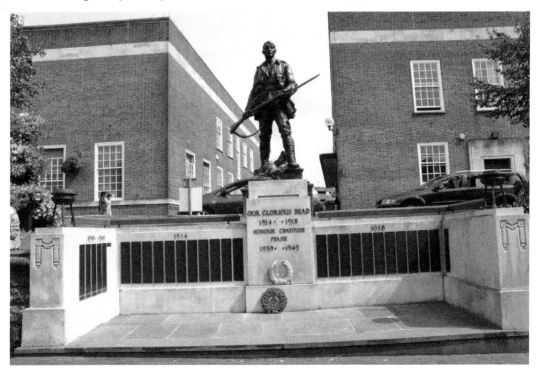

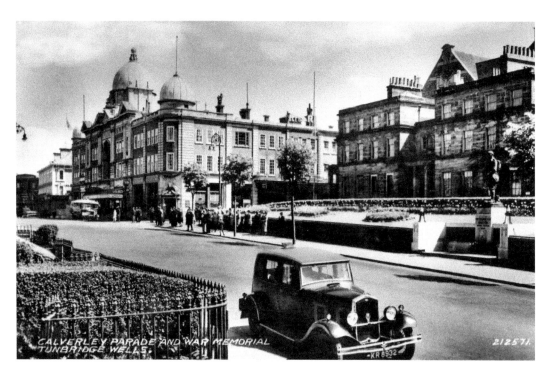

**Museum and Library**

Tunbridge Wells' museum and library are housed in the large red-brick building next to the old opera house on Mount Pleasant Road. The former has among its collections a particularly comprehensive range of Tunbridge Wells' ware. Some of Decimus Burton's fine stone architecture once stood on this site.

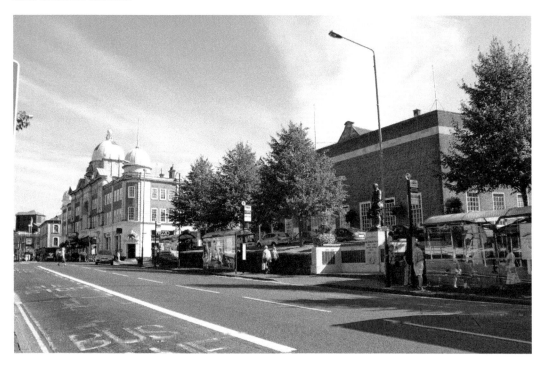

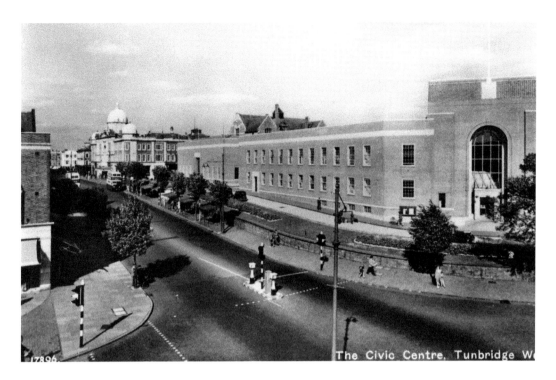

The Civic Centre, Tunbridge W

## Tunbridge Wells Town Hall

The distinctively angular art deco style of Tunbridge Wells Town Hall reflects the fashionable style of the time when it was built in 1939. Conceived some forty years before completion much controversy raged in the interim years as a rear guard reactionary group failed to prevent the demolition of Decimus Burton's Calverley Terrace to be replaced by council offices.

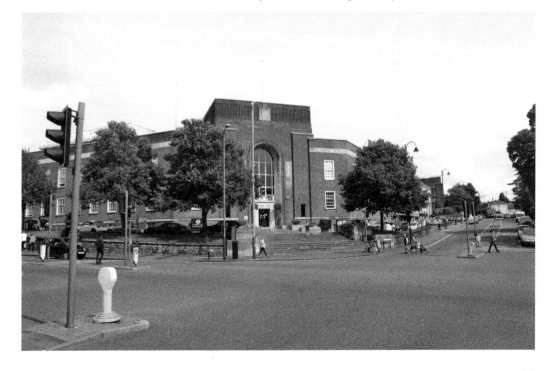

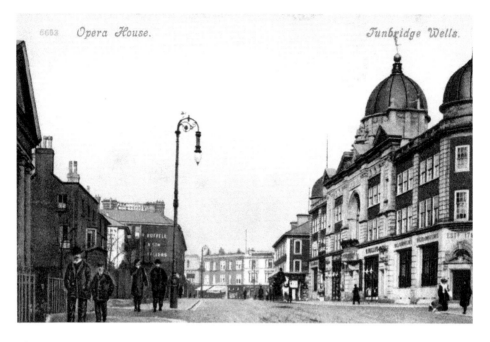

6663 *Opera House.*       *Tunbridge Wells.*

**The Opera House Domes**

Green verdigris covers the copper domes of the Opera House. A statue of Hermes once surmounted one of these, but it has mysteriously disappeared without trace. It probably secretly still exists hidden away in an anonymous garden somewhere!

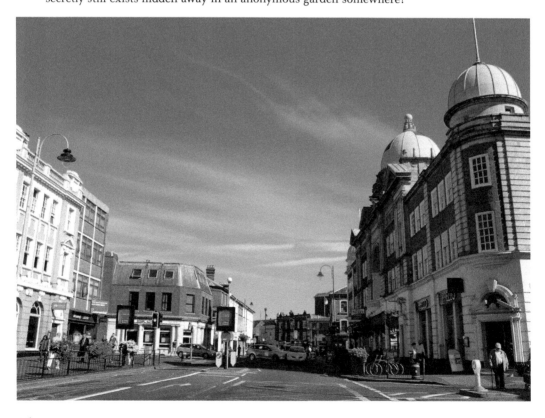

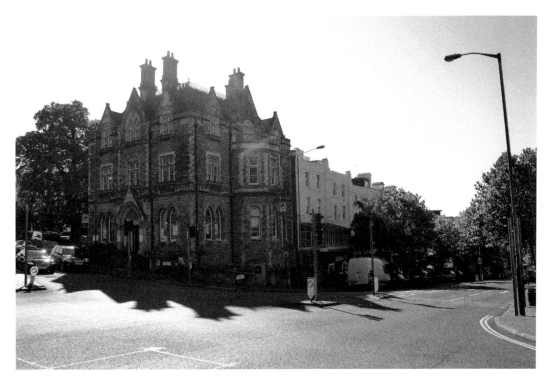

Mount Pleasant I
As these pictures show Mount Pleasant has not altered significantly in appearance over the past century. Originally it was the site of a large brick built mansion belonging to the Earl of Egmont. The extensive prospect from here southwards across the High Weald gave rise to its descriptive name.

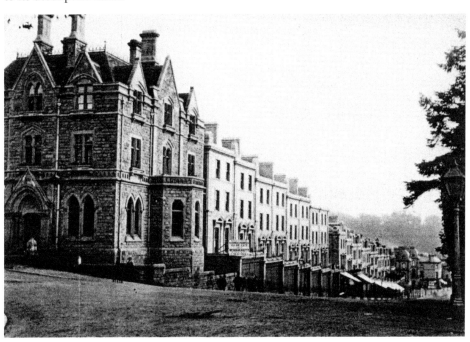

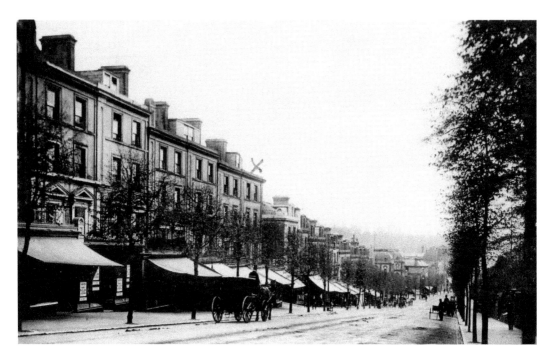

## Mount Pleasant II

Imposing stone built terraces cascade handsomely down the sides of Mount Pleasant towards the railway station at the bottom of the hill. In the eighteenth century a bowling green and assembly room was located here.

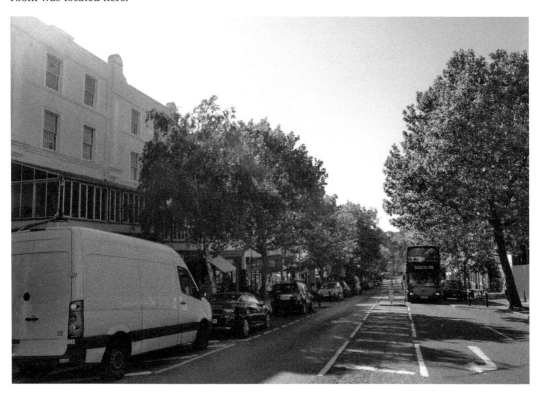

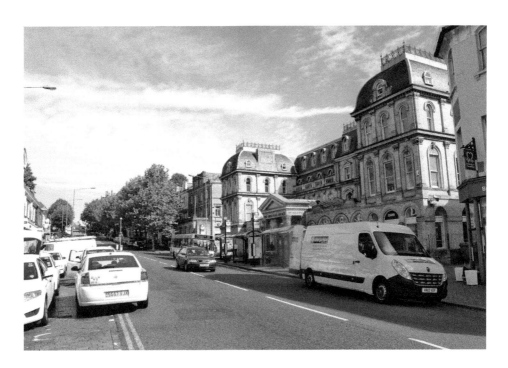

## The Great Hall

The Great Hall is the most central building in Tunbridge Wells. Designed by H. Cronk in 1872, this grandiose edifice resembles a French château from La Belle Époque. Its first purpose was to provide public rooms for community functions. Its hall measured 100 feet by 42 feet and could seat up to 700 people. By the 1920s the Roxy cinema operated here and, after this closed in the 1950s, it eventually became a nightclub venue. This use ended dramatically with a near disastrous fire. At present, following superlative restoration, it is principally home to BBC television and radio studios.

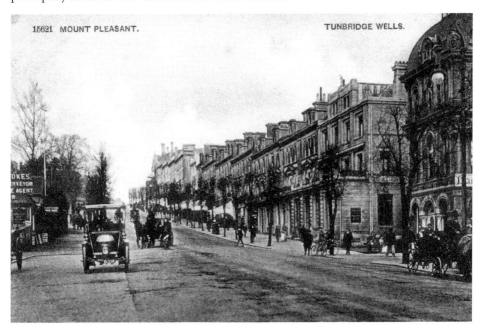

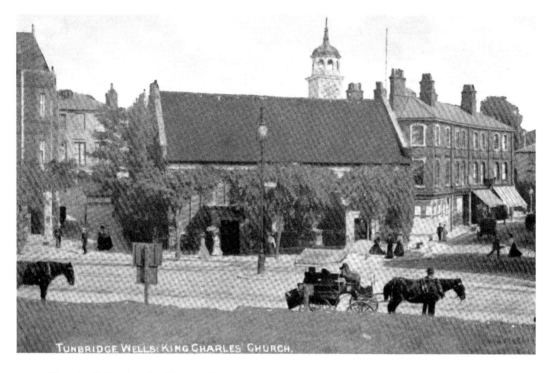

TUNBRIDGE WELLS: KING CHARLES' CHURCH.

### Church of Charles the Martyr (I)

In 1676 the chapel that was built near the Chalybeate Spring was the first building to be erected in Tunbridge Wells. Before then visitors had to lodge at Southborough or Tonbridge. The original design concept was to also provide additional uses of an assembly room and even a shelter from inclement weather. Much altered and enhanced in the last quarter of the seventeenth century; its seating arrangements reflected the town's strict social etiquette with separate pews for servants and trades people.

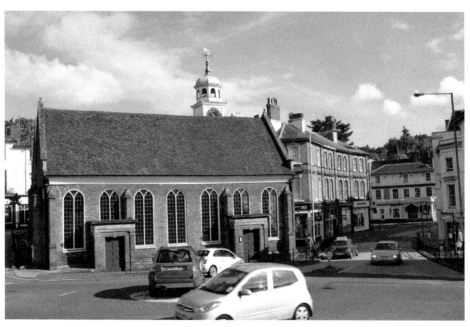

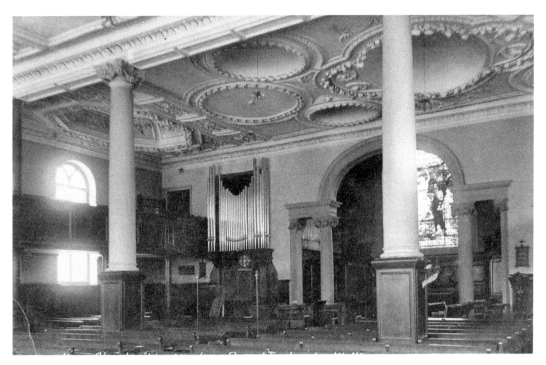

**Church of Charles the Martyr (II)**
Along with the clock tower and a beautiful stained glass window, the ceiling of Charles the Martyr's church is much admired. Perfectly designed and executed by the artist and craftsmen of the day, the observant visitor may notice that in one corner a plaster cherub, jokingly, was made to sport a raffish moustache!

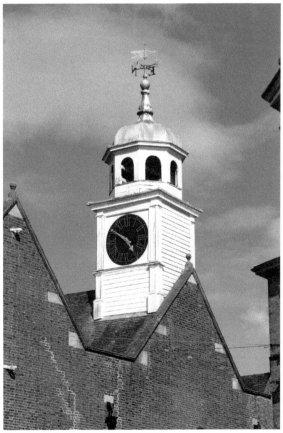

41

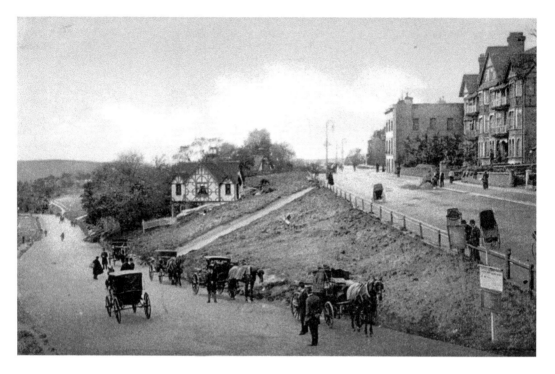

Taxis at Mount Ephraim

The popular postcard image above shows horse-drawn taxis waiting for their 'fares' at a road junction in Mount Ephraim. This is a particularly evocative scene of life in the town a hundred years ago when holidaymakers from London would wish to be driven out to enjoy the leafy commons and spectacular surrounding countryside.

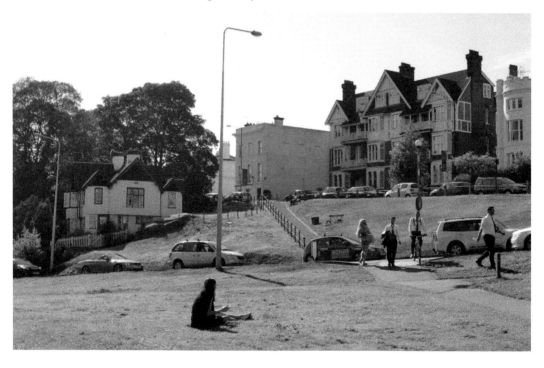

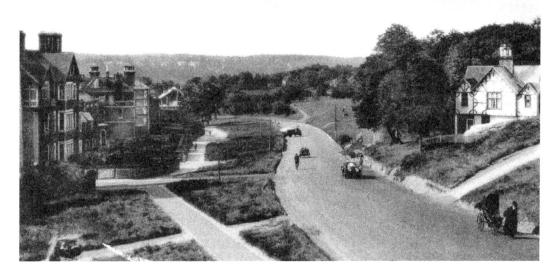

### Early Motorists

Even in an affluent town such as Tunbridge Wells cars were a rare sight in the Edwardian era. Below the London Road at Mount Ephraim, in particular, is now a very busy route quite often choked by slow moving traffic.

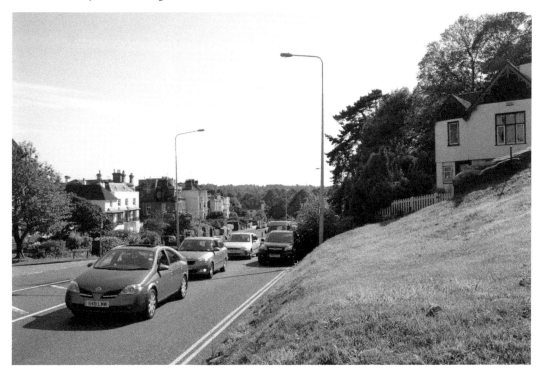

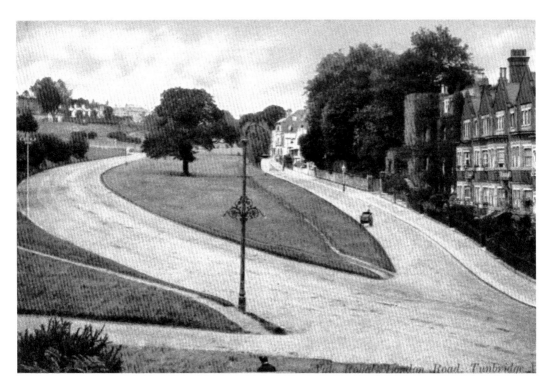

## The Common

After early attempts by developers to encroach on the Common, its preservation was legally protected by statute. Consequently this fabulous outdoor amenity of around 200 acres has been a boon to walkers and sportsmen alike – with even an upper and lower cricket ground.

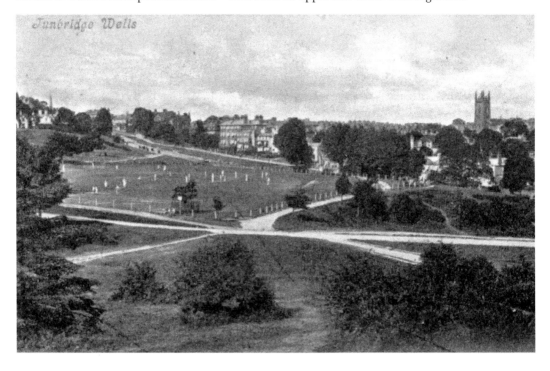

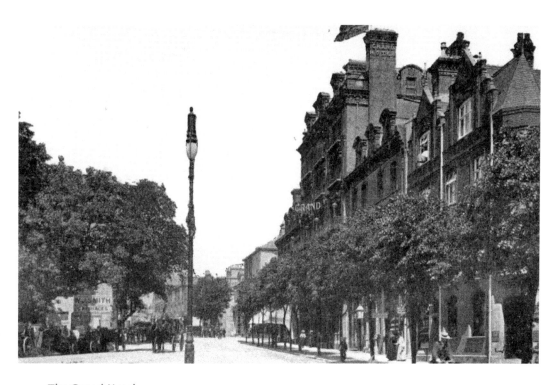

The Grand Hotel

When this large hotel was in its prime a row of waiting barouches would be parked opposite its entrance facing the Common. Its neighbouring building to the right used to be the Cadman Café. Following conversion into flats it has been renamed Kentish Mansions.

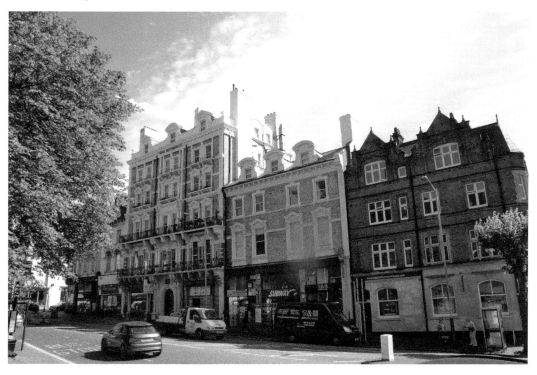

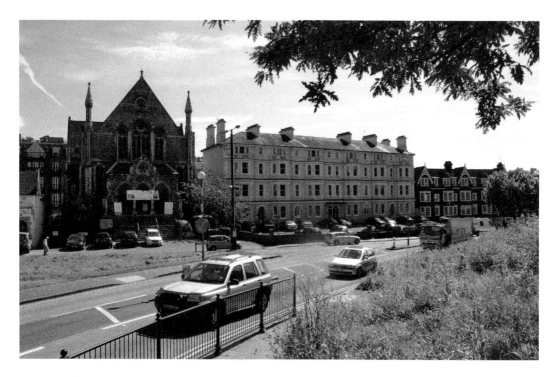

Vale Royal Methodist Church

John Wesley first visited and preached in a house at Tunbridge Wells early in his career. He soon realised that here was a small enthusiastic following. These townsfolk purchased land on London Road and built a small chapel. When this congregation had multiplied greatly a new church called Vale Royal was constructed in 1872 at a cost of £5,000.

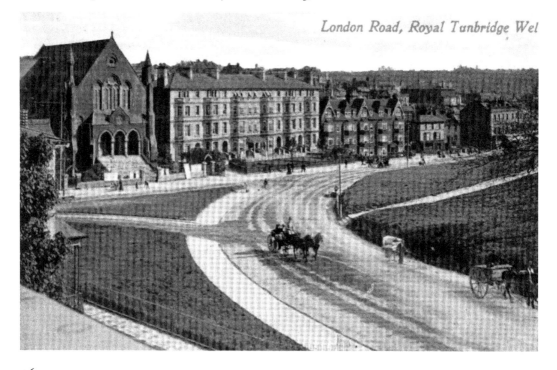

London Road, Royal Tunbridge Wel

**Homes Facing the Common**

Feelings of opulence and freedom encouraged large terraces of desirable houses to encircle the Common. These homes are of such architectural excellence that few changes to their appearance have been required since construction.

22685   Tunbridge Wells.   The Common and London Road.

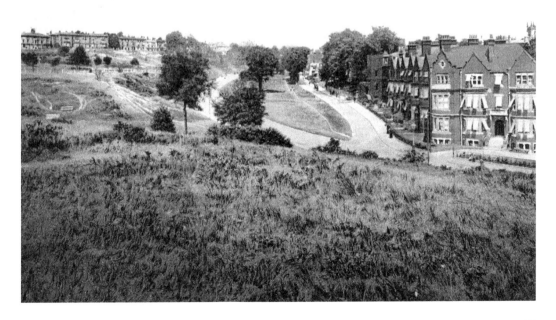

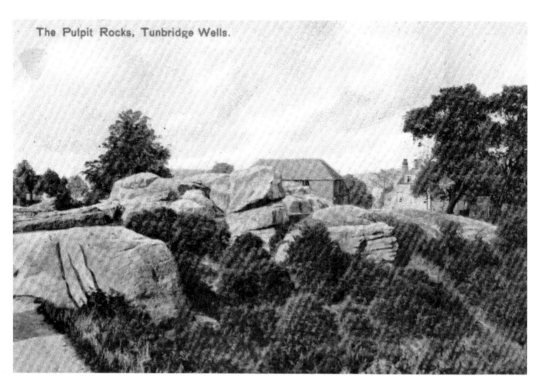

The Pulpit Rocks, Tunbridge Wells.

## Sandstone Rocks on the Common

The sandstone rocks, which are found in and around the town, are Lower Cretaceous in age from 100–140 million years ago. They make perfect play areas for adventurous children to explore.

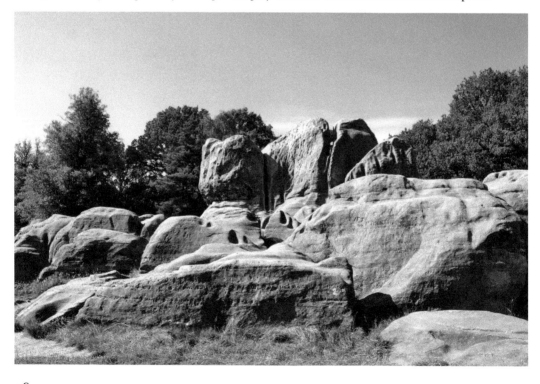

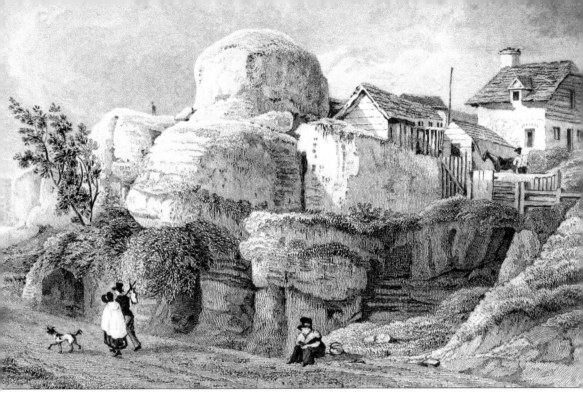

## Gibraltar Cottage

Gibraltar Cottage is most unusual as it looks as if it is conjoined to a large outcrop of rock. However, its pretty position on Mount Ephraim does afford enviable views of the town below.

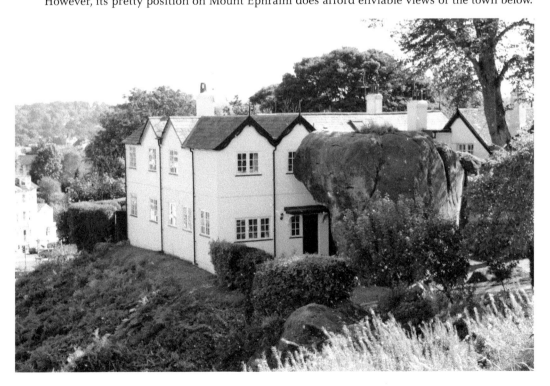

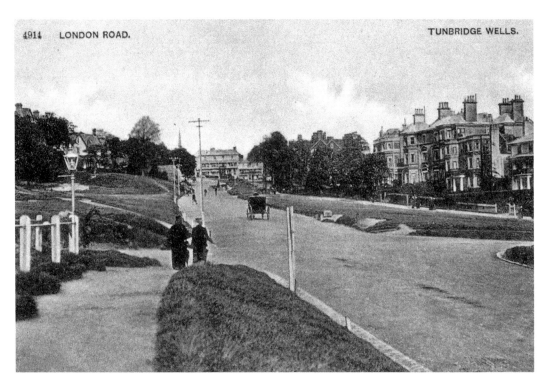

London Road

The main roads south to Lewes and Eastbourne in Sussex meet to form London Road, which goes northward to the Metropolis at the Common. Regardless of high current volumes of traffic, on these routes, the grassy banks of the Common are still a pleasant place to relax and chat to friends.

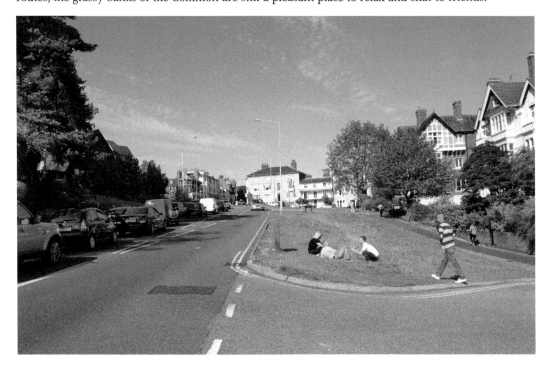

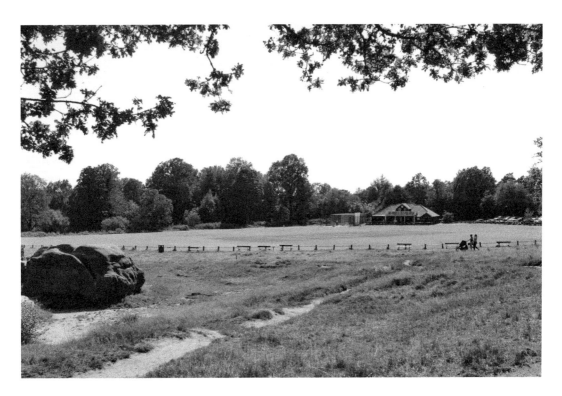

Cricket on the Common

Cricket's origins began in Kent so it has always been a prominent summer sport in this county. The first game on the Common was in 1782. There was a higher and lower ground, but only the latter is now used by the very successful Linden cricket club.

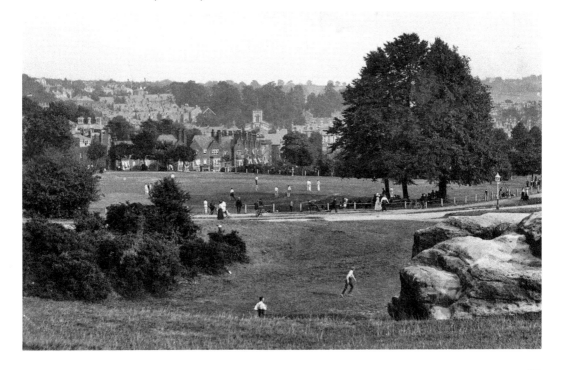

## Common Grazing Rights I

Old manorial laws allowed freeholders to freely graze their animals on common land of the towns or villages. These rights still in many cases exist, but are totally impracticable as it is an offence to enclose common land, and domestic animal owners are legally liable if their stock is the cause of road accidents.

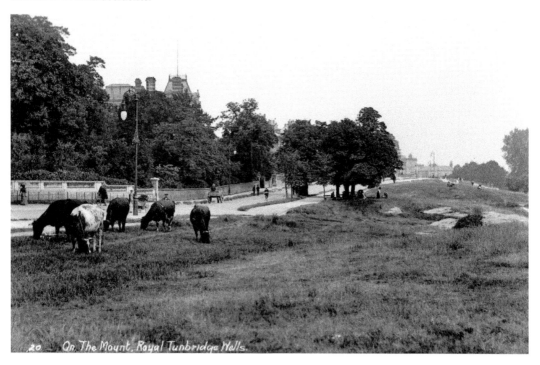

20   On The Mount, Royal Tunbridge Wells.

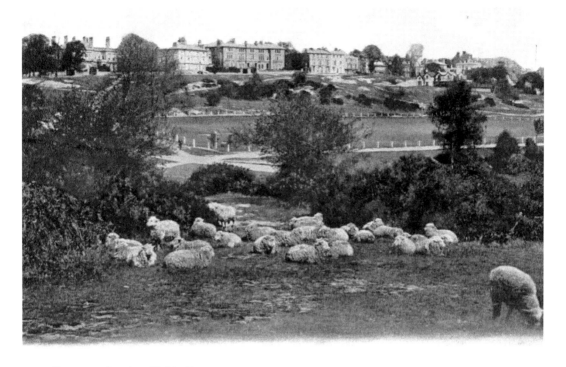

## Common Grazing Rights II

The old scenes of farm animals, roaming freely on Tunbridge Wells Common, seem quite bizarre today, but before the widespread occurrence of motor cars this was a good way to maintain public open spaces without mechanical mowers.

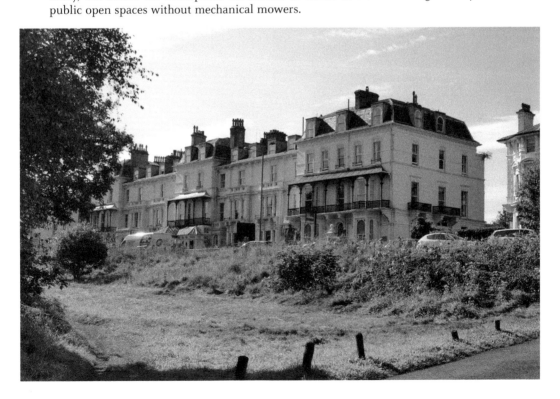

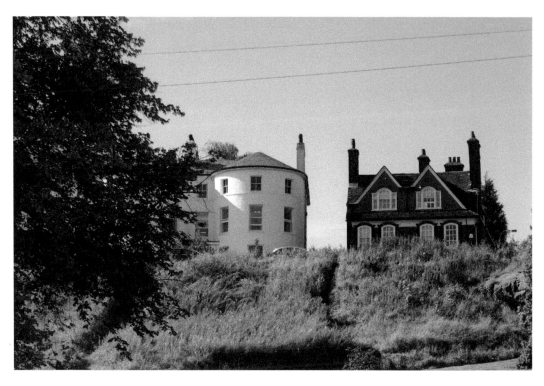

Common Grazing Rights III
Quite often herds of cattle or sheep were watched by low paid boys or shepherds to ensure they were not rustled and did not get lost by wandering off.

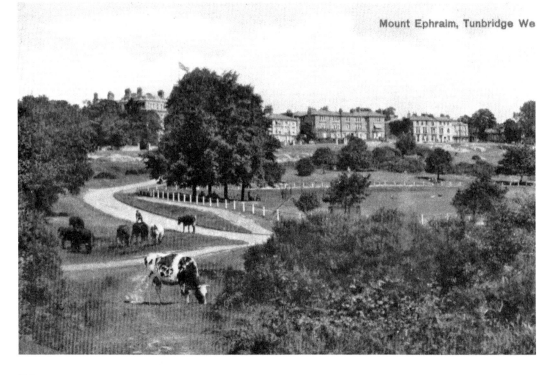

Mount Ephraim, Tunbridge We

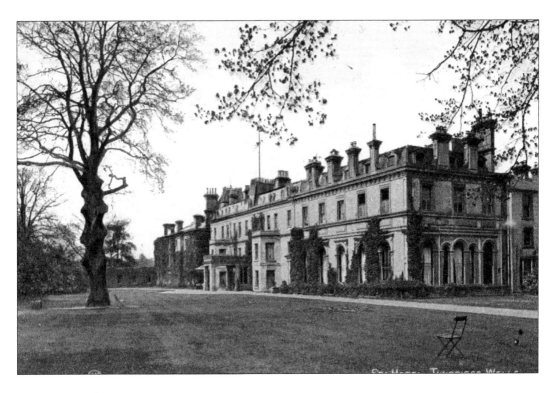

## Spa Hotel

The Spa Hotel is pictured above before its customers needed the use of a car park. This elegant four star hotel is situated in 14 acres of picturesque gardens, on the northern edge of Tunbridge Wells Common.

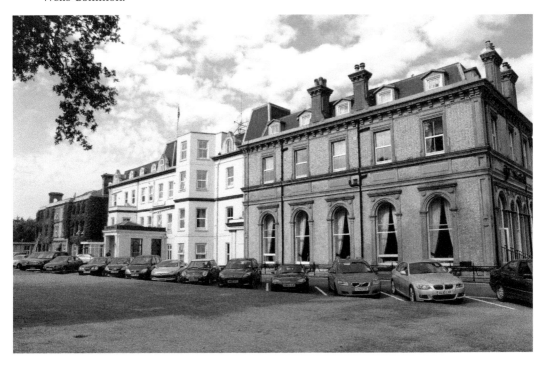

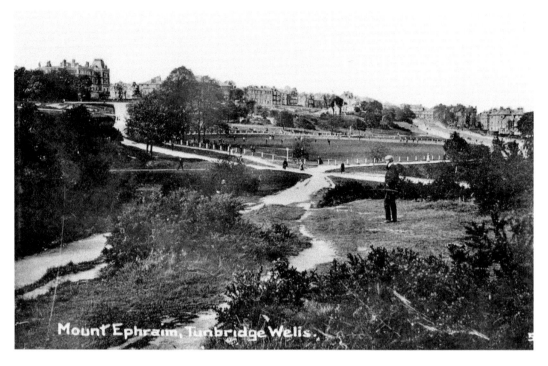

Mount Ephraim, Tunbridge Wells.

### Views Across the Common I
The old picture above gives a view across the common. A sports pitch has been fenced off. Below is a contemporary verdant view, captured in May, which gives a glimpse of church steeples rising above the town below.

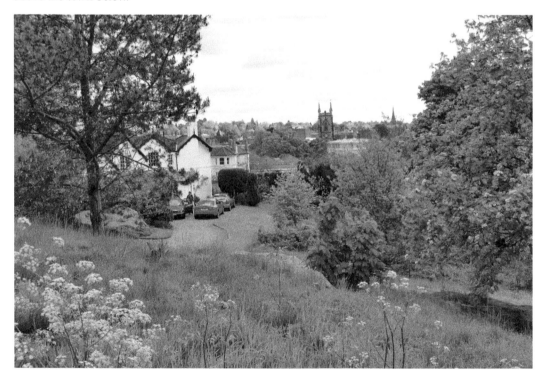

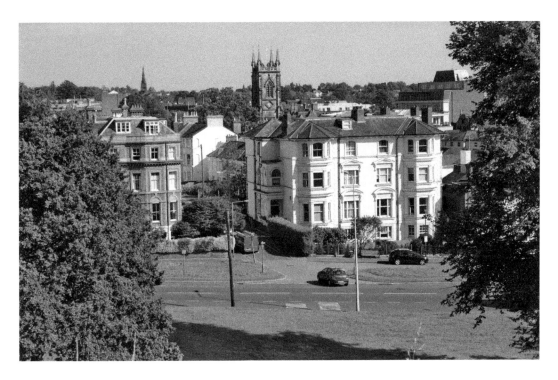

**Trinity Arts Centre**

Trinity church tower, which dominates Tunbridge Wells' skyline, is an early example in the town of the great architect Decimus Burton. This Grade I listed building became redundant as a place of worship in 1975. Its new life as an arts centre is most successful with a combination of shops, a café, a gallery and a small theatre.

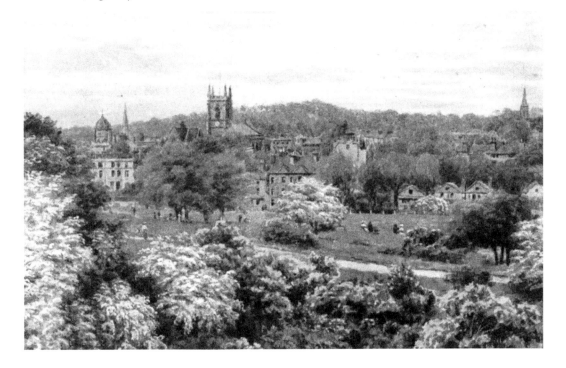

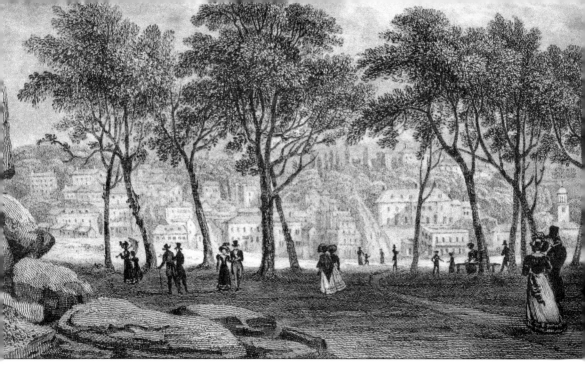

## Views Across the Common to Broadwater Down

The mid-Victorian print above depicts Arcadian walks above the Common where pedestrians enjoyed fine views of the town's rooftops. In the recent snapshot below, the spectacular spire of St Marks, Broadwater, can be seen rising into the sky well above the tree line.

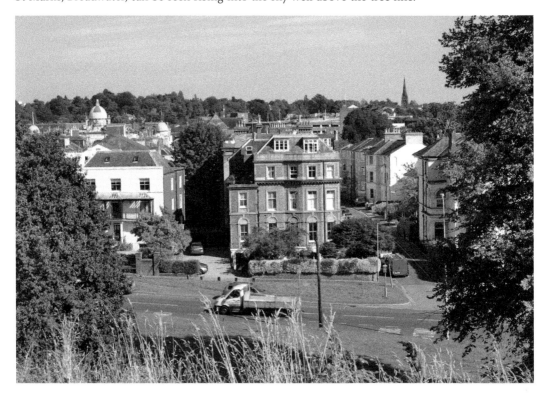

Broadwater Down Avenue

The old landaulet car, parked below, is markedly different from its modern successor above. However, the street scene with its avenues of trees is identical. Because of the large drives, the houses are set back from the road and they are free from the normal plethora of parked cars.

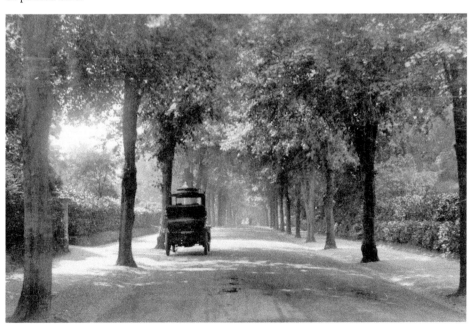

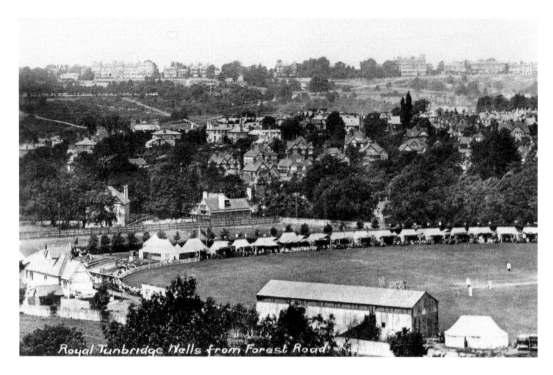

Royal Tunbridge Wells from Forest Road.

### Nevill Cricket Ground

Nevill Ground is a first class cricket pitch where international and county games are occasionally played. It has spectator capacity of 6,000 and was established in 1898. In 1913 suffragettes burnt down the pavilion and although this was soon rebuilt, irreplaceable archives were lost forever.

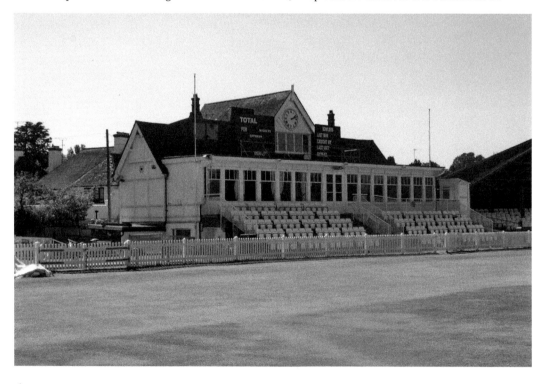

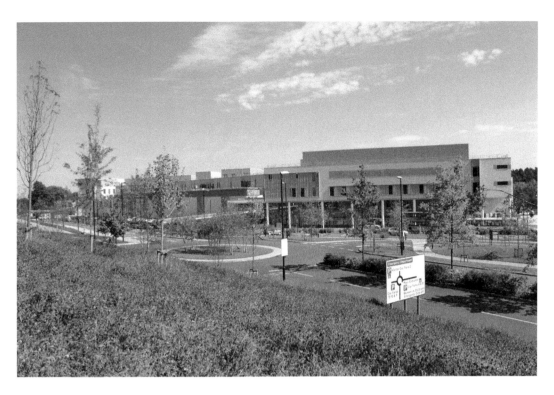

Tunbridge Wells Medical Facilities

A large new state-of-the-art general hospital has recently been built on a green field site near the town at Pembury. Its modern efficient lines are in sharp contrast to the forbiddingly stark crowded Edwardian patients waiting room featured below.

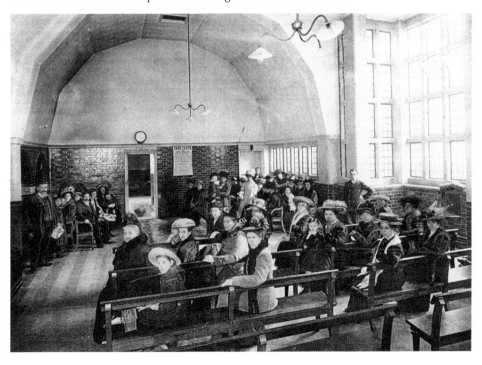

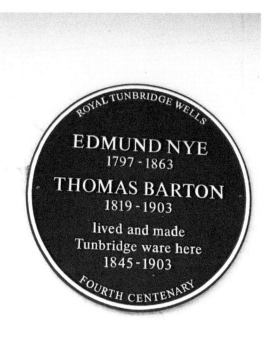

Tunbridge Wells' Ware I
Edmund Nye and his father took over
the premises below when their partner
Fenner retired. In 1836 they were joined
by a Thomas Burton whose excellent
designs were exhibited at the Great
Exhibition of 1851. The claret plaques
found on places of historic interest
celebrate the town's fourth centenary.

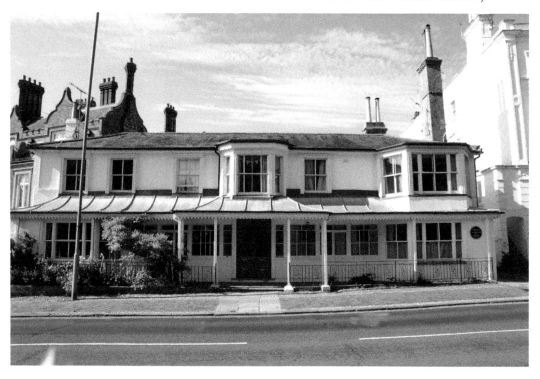

## Tunbridge Wells' Ware II

Tunbridge Wells' ware was made from tessellated mosaic tiles of multicoloured wood. Small useful objects such as glove and stamp boxes were made by local craftsmen who sold them to tourists as souvenirs. When they were originally sold they were modestly priced. However, now these valuable antiques are avidly sought by collectors who are willing to pay well. An excellent display of these fascinating artefacts can be found in Tunbridge Wells' museum.

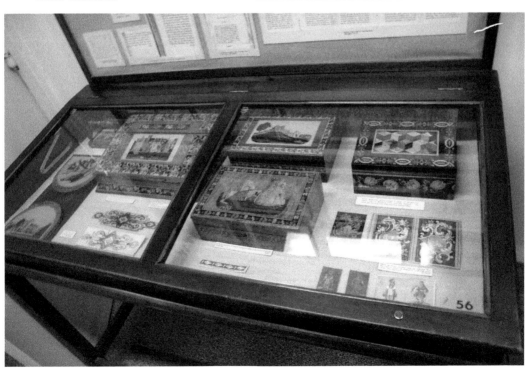

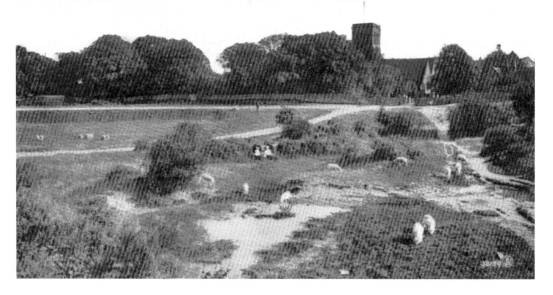

Rusthall

Rusthall is a large village some two miles west of Tunbridge Wells. Its name derives from the iron or rusty spring waters there. During the Civil War the puritans favoured staying in this area while cavaliers preferred Southborough. St Paul's church was built in 1849 and was much less obscured by woodland when it was photographed for the old image above than it is today.

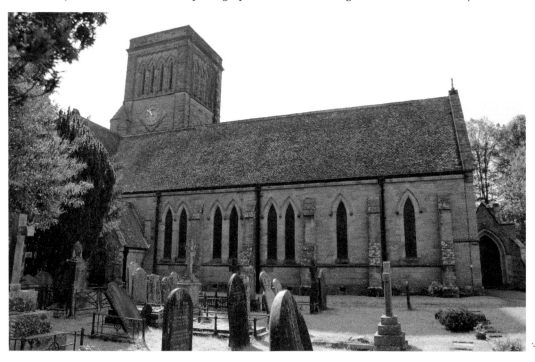

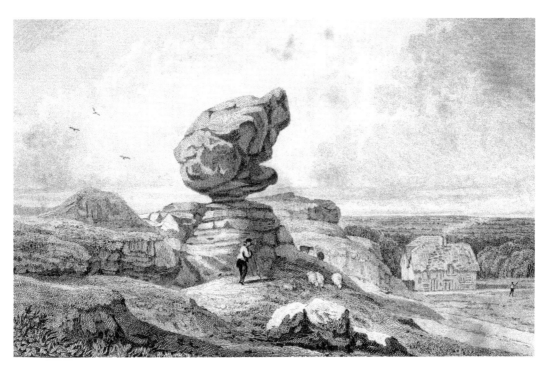

## Toad Rock

The natural sandstone feature at Denny Bottom became known as the Toad Rock around the time of the early nineteenth-century print above. Later tourists arriving by train would be taken in charabancs to see this phenomenon made from part of the rocky outcrop here.

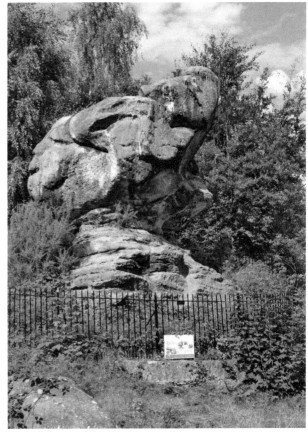

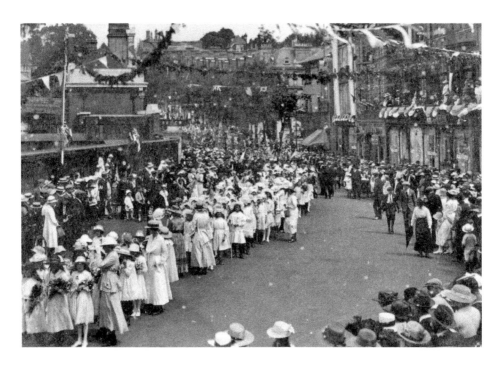

## Great War Peace Celebrations

The old photographs on this page illustrate a large peace celebration at Tunbridge Wells following the end of the First World War. Hundreds of school girls are marching down Mount Ephraim, dressed in white, signifying the merciful end of hostilities.

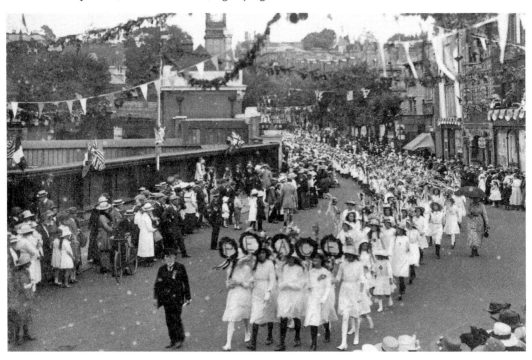

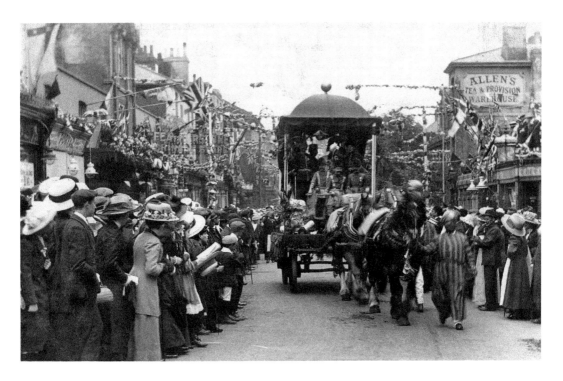

## Coronation Carnival Procession

These lively images from the past show the townsfolk turning out in vast numbers to watch a coronation procession. Maybe, because of Royal Tunbridge Wells acquiring its regal title, a special effort was made. Nonetheless, the colourful horse-drawn floats must have been a colourful spectacle at the time.

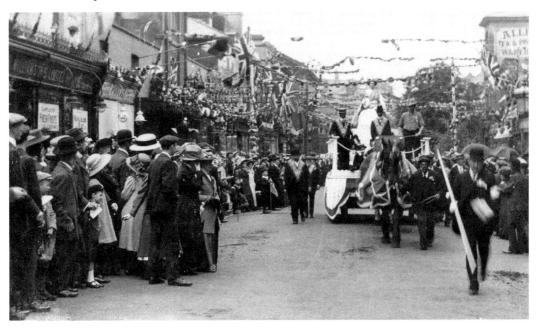

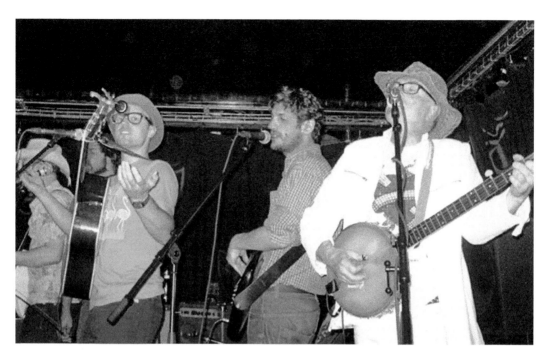

## Local Musicians

The snaps on this page are of the Orange Circus Band, which is a thoroughly unique act based in Tunbridge Wells. Led by Flash Heath, the group plays music inspired by American folk, blues, country and rock.

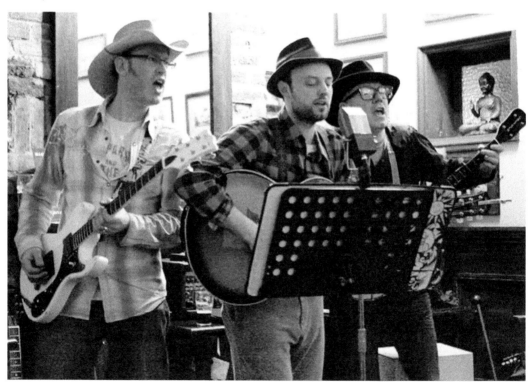

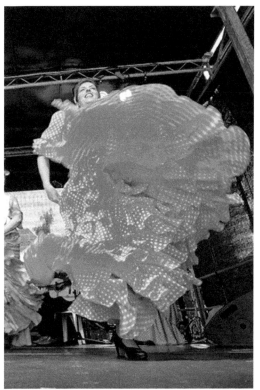

**Flamenco Mosaico**
Tunbridge Wells has
an exceptional range of
societies, clubs and other
organisations available
to join. One of the more
exotic of these is Flamenco
Mosaico, who love to
perform flamenco dancing.
One of their members
Karensa, in the bright dress,
is pictured here enjoying
herself at the Mela.

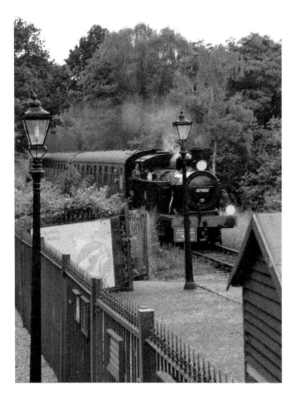

### The Spa Valley Railway I

Affectionately known as the Cuckoo Line, the Spa Valley Railway runs between Tunbridge Wells and Eridge. It was opened in 1996 following a long campaign to purchase it from British Rail. The heritage line provides a way of getting to tourist attractions such as the Pantiles, High Rocks and Groom Bridge Place.

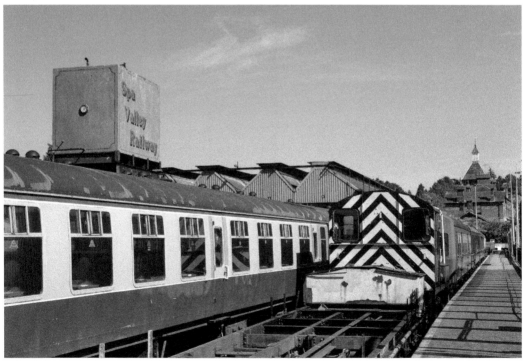

### The Spa Valley Railway II

The old grandiose Tunbridge Wells West railway station closed in 1985. Most of its buildings have been converted into a theme pub. However, the traditional ticket office below has been retained for the Spa Valley Railway and is painted in South Eastern Railway's livery colours of green and cream.

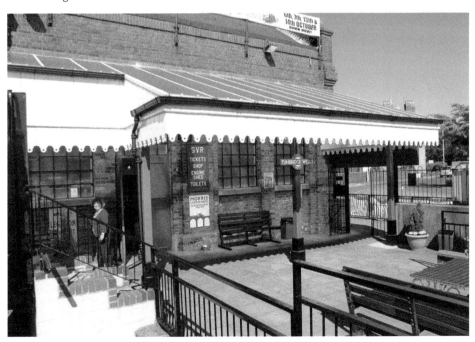

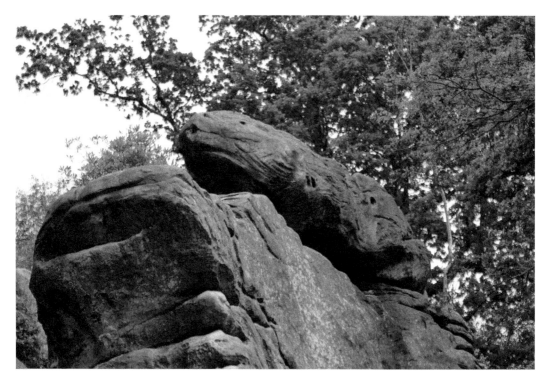

High Rocks (I)

The High Rocks became a tourist attraction following a visit to Tunbridge Wells by James II. It is now a Site of Special Scientific Interest. The nearby creeper clad hotel, photographed below, welcomes sight seekers needing refreshment after climbing over the stones.

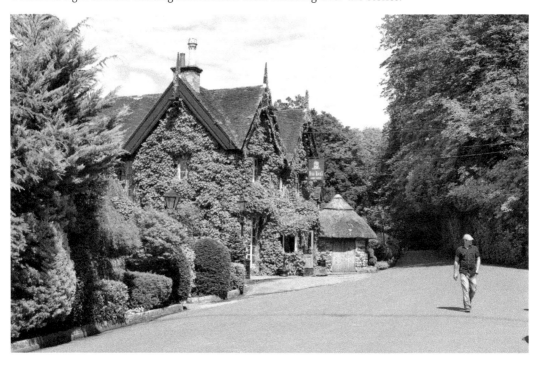

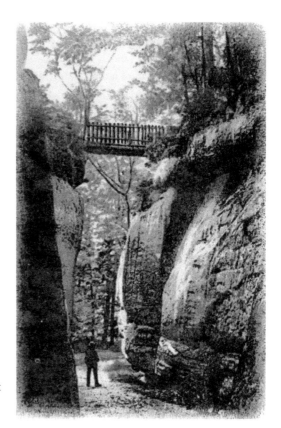

**High Rocks (II)**
The Aerial Walk, a series of bridges linking the tops of the crags was built in the nineteenth century to cater for increased interest.

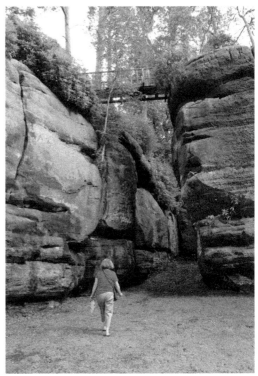

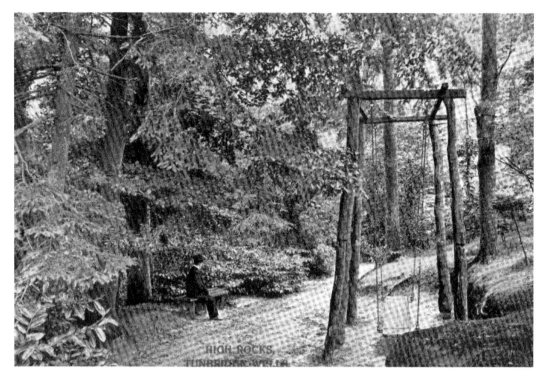

## High Rocks (III)

The 8 acres of wooded grounds are an ideal venue for picnics, or just a peaceful place to rest awhile and enjoy the great outdoors. These pictures show how well the atmosphere of tranquillity has been preserved over the years.

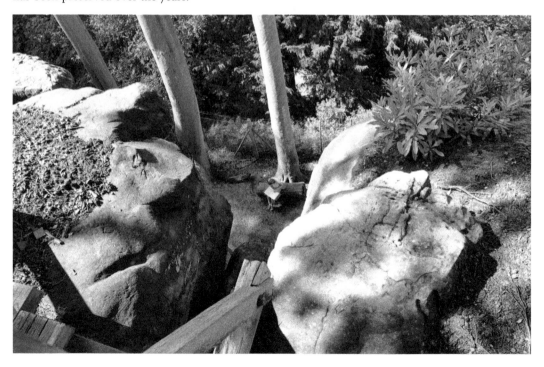

Happy Valley, Royal Tunbridge Wells

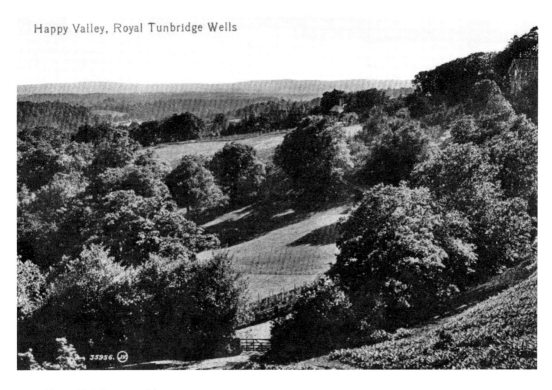

### Beautiful Countryside

Parks, woods and commons fill and surround Tunbridge Wells. These old postcard images are good examples of the lush rolling countryside, which fortunately still exists.

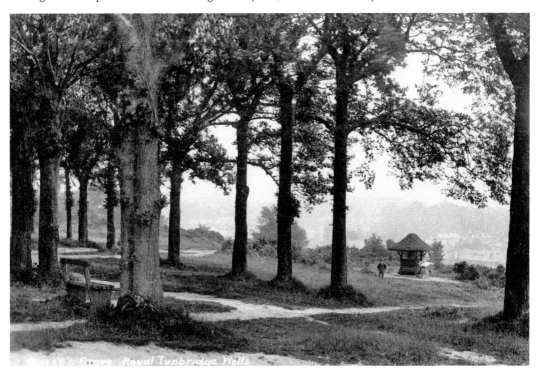

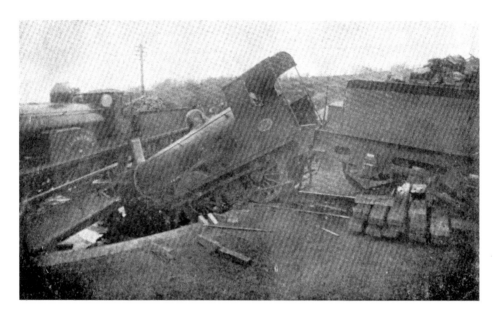

Railways I

Above, a postcard picture shows an accident on 11 March 1905 when a large goods engine fell into the turntable pit at Tunbridge Wells West. Accidents were a surprisingly popular subject for early postcards. Below, the Southern Railway hoarding gives directions to the towns two stations when Central was for Charing Cross and West was for Victoria.

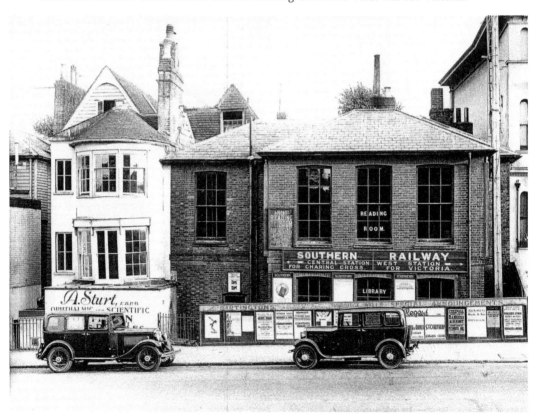

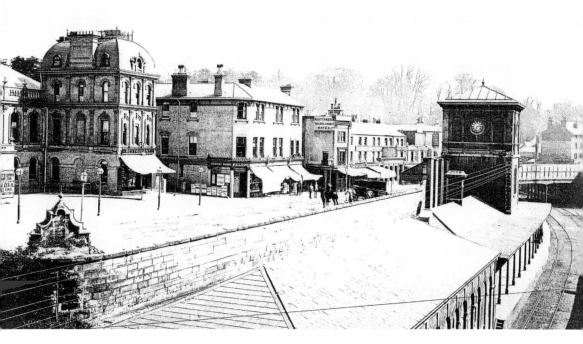

## Railways II

The period shots on this page show Central station in the days of steam. There seems to have been scant regard for health and safety concerns as bewhiskered officials in silk top hats wander casually onto the track close to a hissing locomotive.

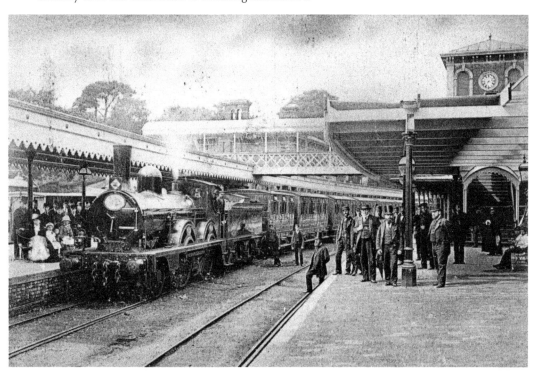

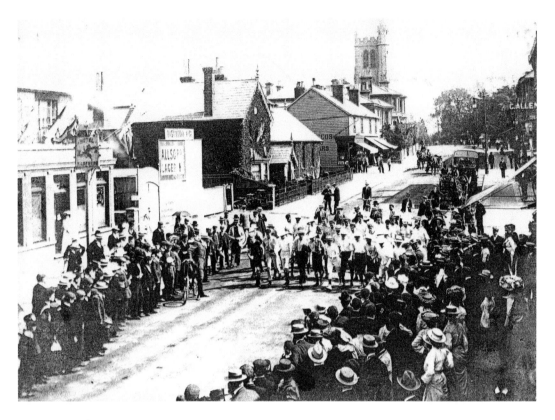

### Fun and Games

The old photographs on this page show some of the ways in which the town's youth used to enjoy themselves. Above, a road race is about to start near St John's church. No skimpy shorts or Lycra were worn then; only straw hats and long white flannels. A police children's party of 1931 below looks relatively restrained by today's standards.

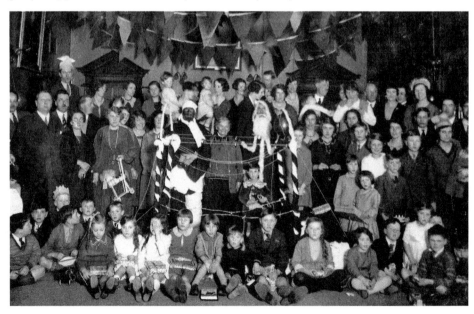

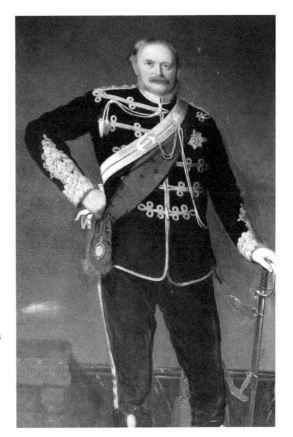

**Eridge Castle I**

Eridge Park is thought to be the oldest deer park in England. It has been the ancestral home of the Nevills since they inherited it in 1448. The portrait, right, which hangs in Tunbridge Wells' museum, is of William, Marquess of Abergavenny – painted by Sidney Hodges in 1887. Edward, Lord Abergavenny, sank the first well over the Chalybeate Spring in 1606. The Tunbridge Wells' ware pattern below of Eridge Castle was a popular subject for designs on these Victorian souvenirs.

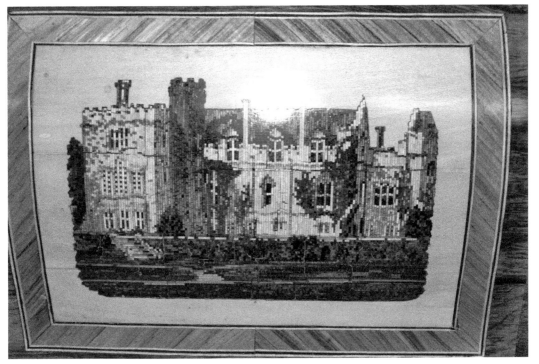

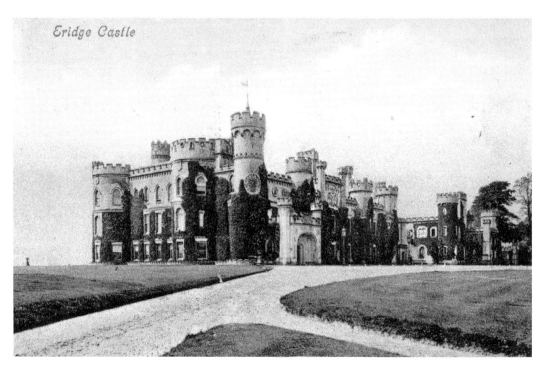

*Eridge Castle*

Eridge Castle II
In 1787 Henry Nevill, the 2nd Earl of Abergavenny, began building Eridge Castle in exuberant Strawberry Hill Gothic style. This stood until the late 1930s when it was demolished and replaced by a Georgian style mansion house below.

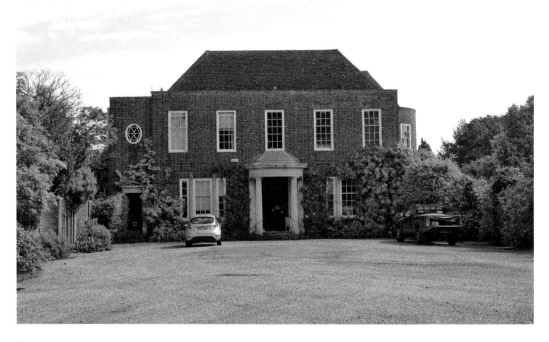

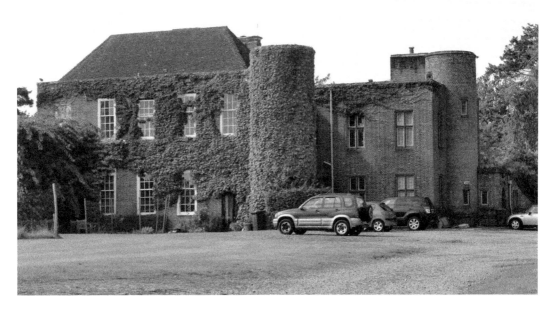

## Eridge Castle III

The present Eridge Castle estate comprises many enterprises using converted buildings. In Victorian times the Prince of Wales often visited to join shooting parties. It is said Disraeli came because he enjoyed the quality of the venison and strawberries. The Nevill motto – *ne vile velis* – is a Latin play on words, which roughly translated means 'wish nothing base', and is seen below on a plaque attached to an old estate building.

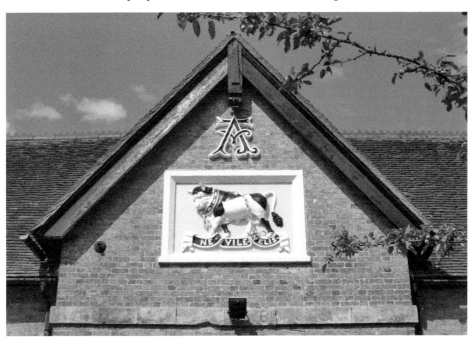

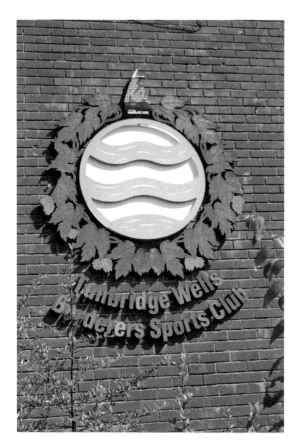

**Tunbridge Wells Rugby Club**
Tunbridge Wells' Rugby Club is part of
the Tunbridge Wells Borderers Sports
Club, and play their home fixtures at
St Mark's recreation ground. The
club was originally formed as the Old
Skinners in 1931, but changed to be
an 'open' club in 1973. In 1985 a new
clubhouse was opened by Princess Royal.
Most famous of the former players is
Martin Corry who was part of England's
2003 world cup winning squad.

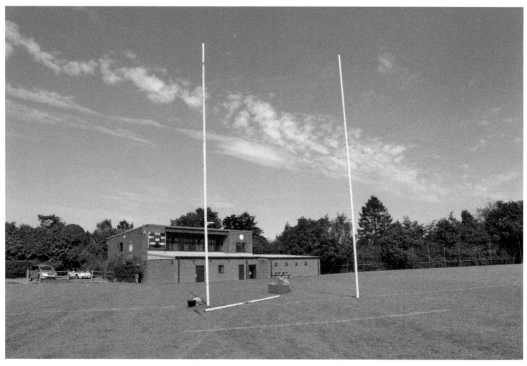

## Tunbridge Wells Golf Club

Tunbridge Wells Golf Club was established in 1889. The course still maintains its stunning views designed by its Victorian founders. Chatting at the clubhouse bar below are Peter Annington (Club Secretary) and Ian Randle (Head of House).

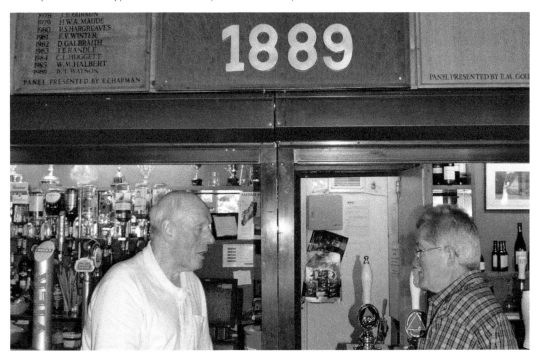

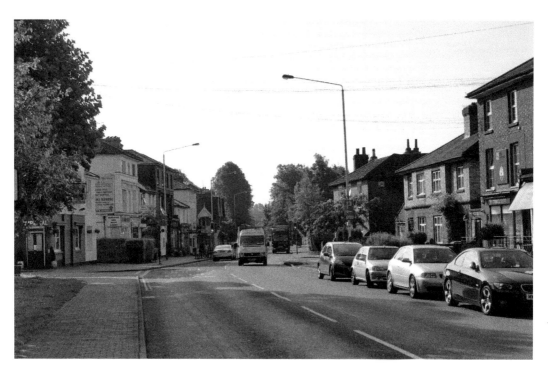

Southborough I

Southborough has a long industrial tradition, with iron being mined here from prehistoric times. In the late eighteenth century gunpowder was made at Powder Mill Lane. Not surprisingly, this area is renowned for cricket and the town became a centre for ball manufacturers. The main London Road, which passes southwards to Tunbridge Wells, is much less sleepy now. Compared to the scene below, cars have become our main means of transport.

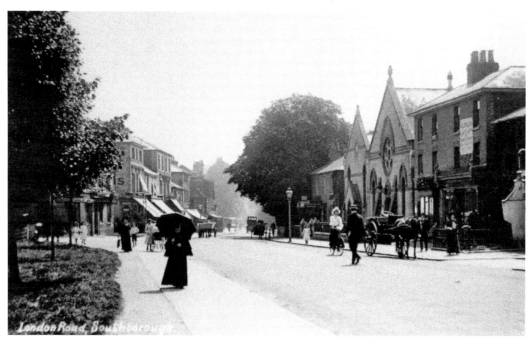

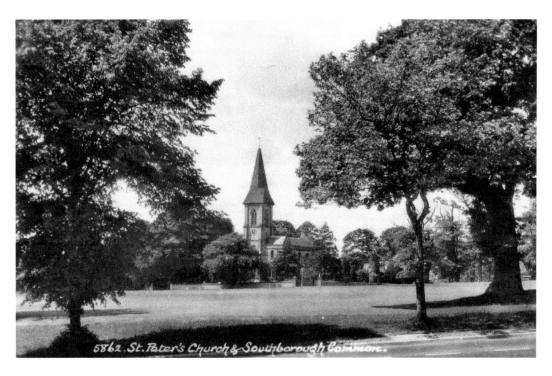

5862. St. Peter's Church & Southborough Common.

## Southborough II

Pleasingly, these views of St Peters Church, Southborough, show no changes over the decades that they were taken. This is another beautifully proportioned example of Decimus Burton's work, which stands majestically by the trimly kept cricket green.

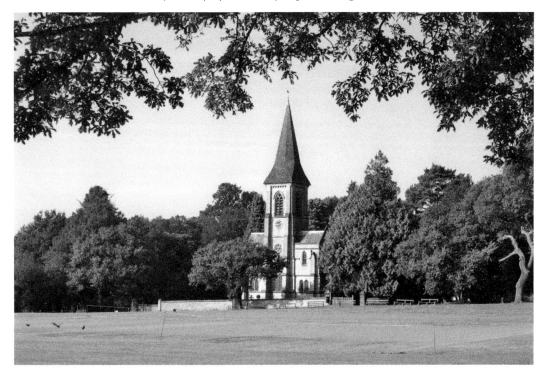

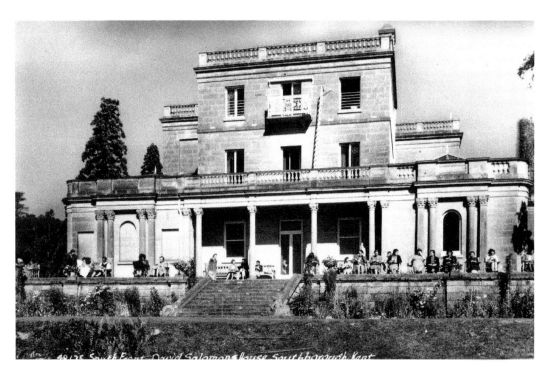

## Salomans I

Salomans, as it is now called, was the home of rich Jewish financier and politician David Salomon. Decimus Burton's unique architectural signature is written all over this impressive stone structure. Now occupied by Christ Church University, it has previously served as a hospital and convalescent home.

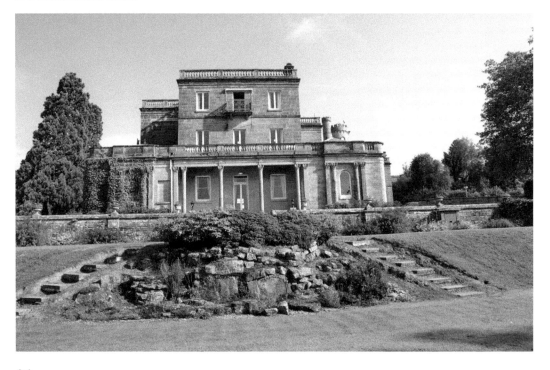

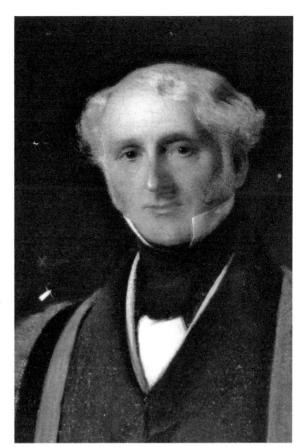

**Saloman II**

David Saloman pictured right was the first Jewish peer to sit in the House of Lords. He is also credited with being the pioneer to introduce motor cars to this country. Attached to the main house are perhaps the earliest purpose built motor car garages to be erected. They are, however, far less imposing than the palatial stables below, which resemble more of a baroque French château than a shelter for horses.

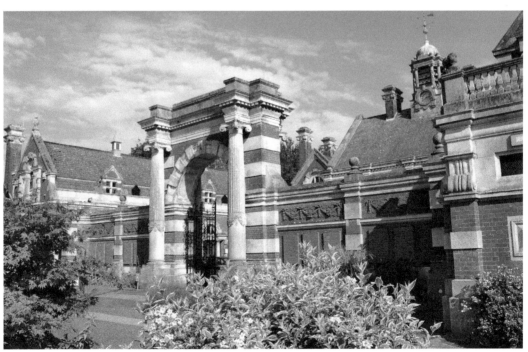

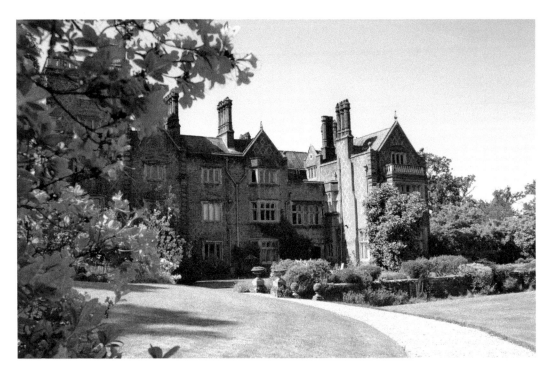

Hall Place, Leigh

The present Hall Place was built in 1878, although the manor house for Leigh has stood here since the seventeenth century. Close to the picturesque village green of Leigh, the house has spectacular gardens. These are occasionally opened to the public by the Hollenden family under the gardens for charity scheme (NGS).

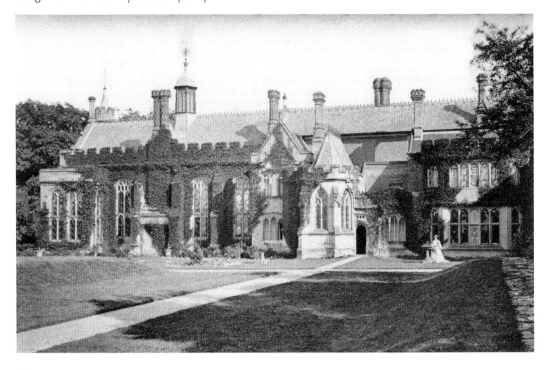

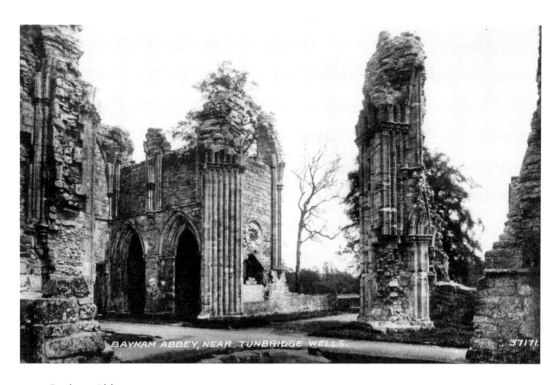

### Bayham Abbey

Situated on the Kent Sussex border near Frant, Bayham Abbey was built of local sandstone by thirteenth-century Premonstratensian cannons. Suffering the usual fate of such religious centres during the Reformation, its ruins are now a romantic landmark managed by English Heritage.

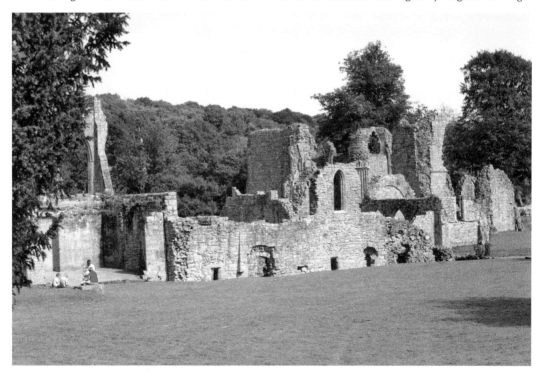

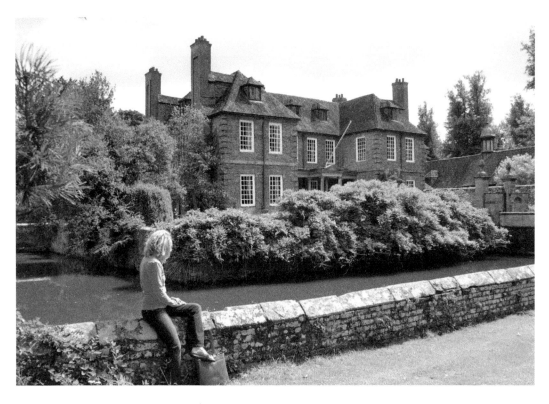

Groombridge Place

Groombridge Place is a manor house, with a moat, built for architect Philip Packer in 1662. He was a friend of Christopher Wren who helped him in this venture. Earlier manor houses had stood on this site since 1239. With sensitive conservation the symmetrical proportions of this mansion have altered little over the past 350 years. The formal gardens, vineyards and bird of prey sanctuary have made it a tourist attraction. However, the interior of the house is not open to the public.

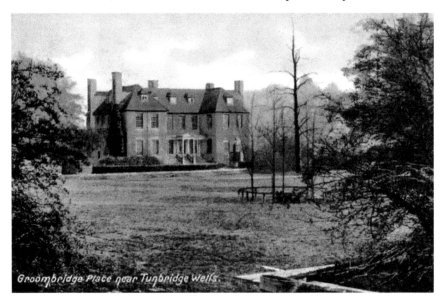

Groombridge Place near Tunbridge Wells.

**Penshurst Place**
Penshurst Place is a good example of a large nobleman's residence, built at a turning point in medieval times when such buildings were no longer merely military fortresses. Owned for centuries by the Sidney family, it boasts one of the oldest private gardens in England.

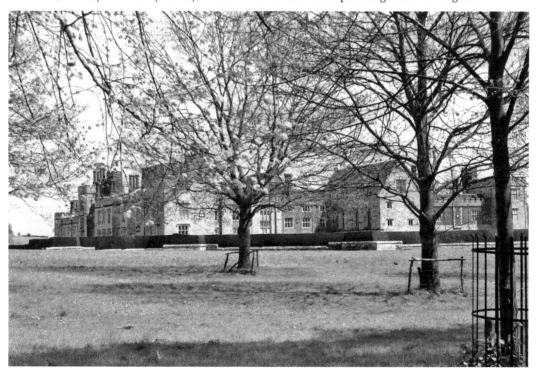

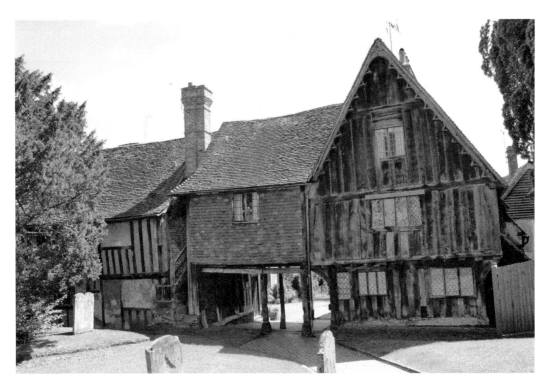

Penshurst Village
These picturesque buildings nicknamed the original 'Leicester Square' are called this as the Sidney family once held the title Earl of Leicester. They are close to the parish church of St John the Baptist, where there are many memorials to the distinguished local leading family.

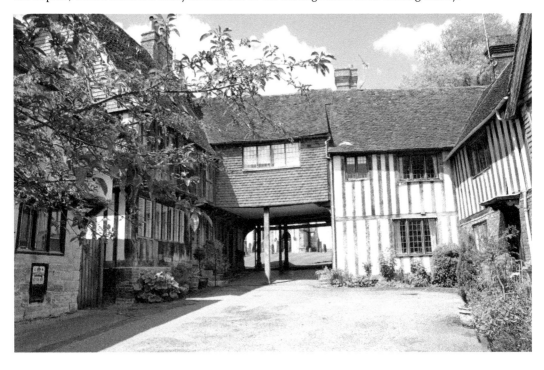

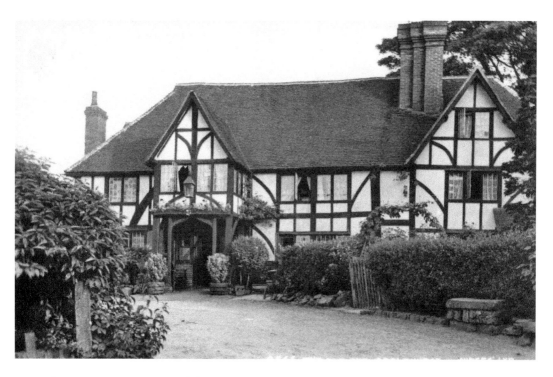

**The George & Dragon, Speldhurst**
The George & Dragon, Speldhurst, is thought to be the second-oldest public house in the country. Its lovely thirteenth-century timber frame invites customers in to indulge in the gastronomic pleasures of good pub grub.

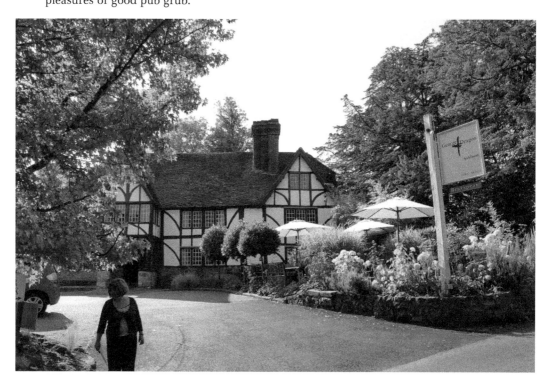

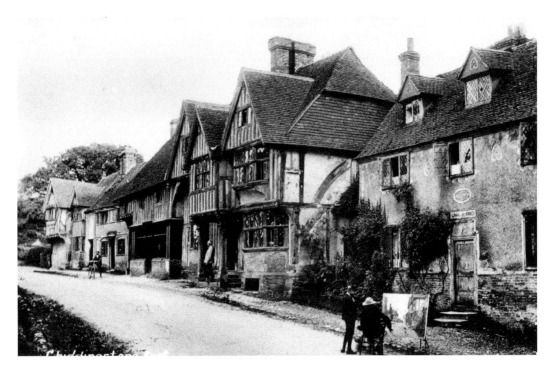

## Chiddingstone

Chiddingstone village, apart from the castle and church, is owned by the National Trust. It has been described as the most perfect Tudor village in England. So immaculately conserved is its main street that it is often used as a set by film-makers. One theory of its name derivation is that it comes from the Chiding Stone, which was the seat of judgement for the admonishment of overbearing wives.

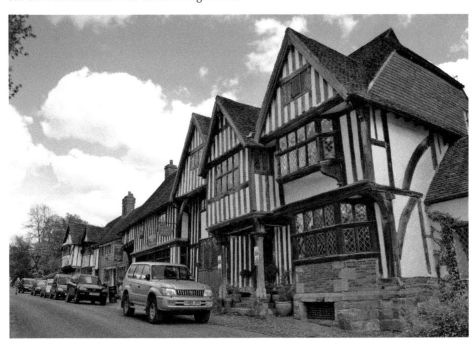

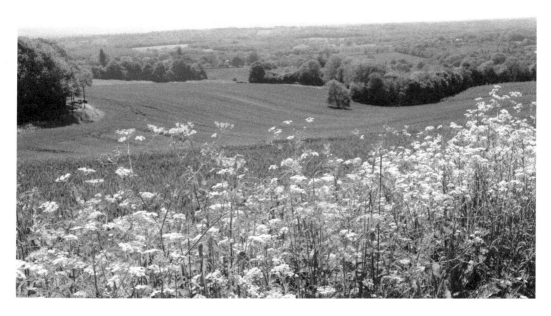

## Beauty of the Seasons

Part of the joy of the Tunbridge Wells is that it is surrounded by beautiful villages and sublimely perfect countryside. The summer and winter snapshots here eloquently prove this comment so readers might be seduced into possible forays to experience it for themselves.

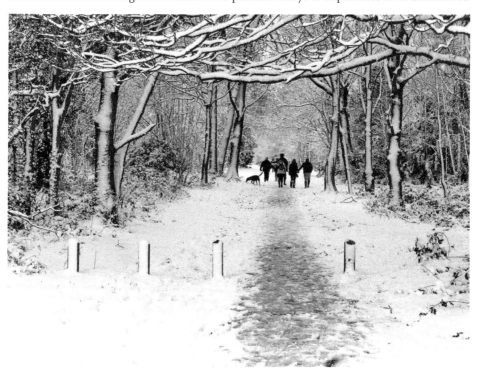

# Acknowledgements

First and foremost I wish to acknowledge my deepest gratitude to my beloved partner Jocelyn for her unceasing help and encouragement. Thereafter, thanks go to Chris Rapley who hired a group of postcards to be scanned. I would like to show my appreciation to Amanda Lynch, Patsy Newman, Caroline Bray and Jo Elvy who have each made valuable contributions. Should I have failed through any error of omission or commission, to include anyone who has made a contribution in any way, I apologise and will naturally include their details in any subsequent reprint.